PAINTING THE EFFECTS OF
WEATHER

•

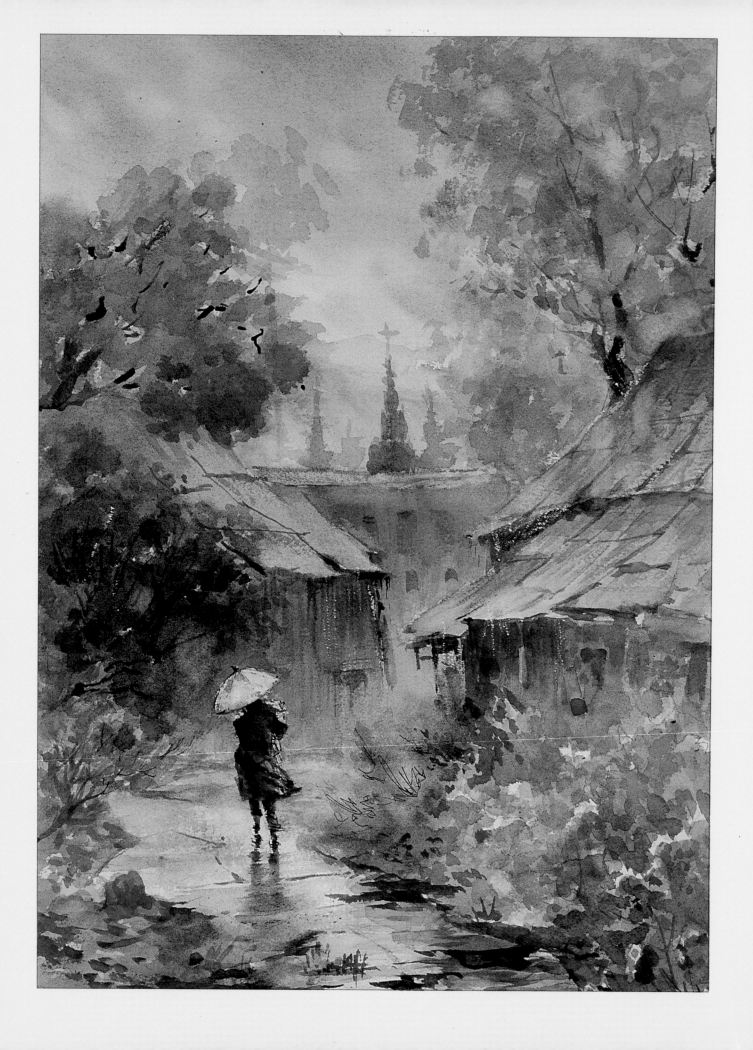

PAINTING THE EFFECTS OF
WEATHER

•

Patricia Seligman

Rainy Morning,
LaVere Hutchings,
watercolor.

NORTH LIGHT BOOKS

Cincinnati, Ohio

A QUARTO BOOK

First published in the U.S.A. by North Light Books,
an imprint of F & W Publications, Inc,
1507 Dana Avenue, Cincinnati, Ohio 45207

First published 1992
Copyright © 1992
Quarto Publishing plc

ISBN 0-89134-486-1

Senior Editor: Kate Kirby
Senior Art Editor: Penny Cobb
Designer: William Mason
Editor: Angela Gair
Photographers: John Wyand, Paul Forrester, Ian Howes
Picture researcher: Mandy Little
Picture manager: Sarah Risley
Art Director: Moira Clinch
Publishing Director: Janet Slingsby

Typeset by Central Southern Typesetters, Eastbourne
Manufactured by Regent Publishing Services Ltd, Hong Kong
Printed by Lee-Fung Asco Printers Ltd, Hong Kong

CONTENTS

Introduction

Anyone who has tried to capture on paper or canvas the speed of racing clouds, the sparkle of sunlight, or the iridescent blue of a summer sky, will know how difficult it can be. The weather, in all its guises, is not an easy subject to paint, but it has to be one of the most exciting and inspiring, not only for the landscape artist but for painters of almost all subjects and in all styles.

But what exactly do we mean by "painting weather"? In this book we understand it as recording the effects of various types of weather on our surroundings. Most of all, this involves depicting the sky. But the sky is not essential: the effects of weather – dappled sunlight, snow, ice, mist, rain – can be shown without including the sky. As far as subject matter is concerned, again it might seem obvious that landscapes predominate in a book on painting weather. But you will see many other backgrounds on which to integrate the effects of the elements – pictures of buildings, people – in many different styles.

There are some artists who specialize in painting the elements, who go out in search of a force nine gale and crashing seas and paint in situ. Others, following the example of the great English landscape painter John Constable (1776–1837), fill sketchbooks with observations of cloud formations and the effects of changing weather on nature – information which can be used as a part of an artist's vocabulary in composing a picture at a later date.

The glory of using the weather as a subject is that it is always to hand. There is no problem about searching for inspiration. You can study it conveniently from the warmth of a room, or you can encounter it at first hand, outdoors, where the smell of the grass and the warmth of the sun contribute to the experience. And what you see outside your window does not have to be reproduced faithfully; it can simply act as a catalyst for your creativity when what you are trying to capture is a mood or sense of place rather than a purely physical representation.

I personally like painting weather simply be-

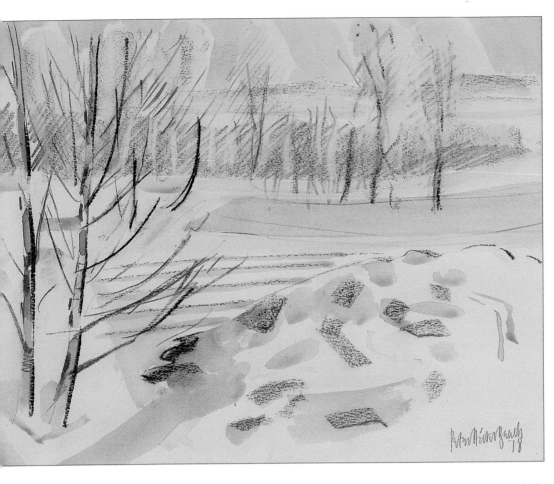

Snow at Williamstrip,
*Peter Hicks Beach,
watercolor, pencil, and
pastel.*
Mapping out the rhythm of
the landscape with flat
washes of translucent
watercolor, the artist has
then added linear detail and
texture with pencil and
brown and black pastels.

cause it happens to coincide with my enjoyment of being outdoors. I do have to admit to being a fair-weather painter, but there are plenty of artists who would reject a balmy summer's day in favor of a bland, gray day which does not reduce the landscape to extremes of light and shade. Despite the pleasures, painting outdoors does pose its own problems – clouds of insects, gusts of wind, sudden showers, to mention but a few – which will be reviewed in the first chapter of this book. It is a practical chapter with suggestions on the most appropriate media for outdoor work and advice on what equipment to take with you.

Following this, we will look at various aspects of reproducing weather effects, from painting different types of cloud to creating sparkling light and luminous shadows. We will focus on problem areas, such as how to mix colors for a blue sky, or how to paint a volatile mass of vapor, in other words a cloud, without making it look as heavy as a rock. These will be carried out in whatever medium is most appropriate, but in the course of the book, oils, acrylics, watercolor, and pastels are discussed in depth. Each chapter is illustrated with relevant examples of works by professional artists in a wide variety of styles, and paintings by the great masters are included to illustrate particular points.

The book not only covers the physical representation of weather effects, but also looks at how you can harness the elements to underline the mood of your painting, or even to strengthen its composition. A beach scene in high summer, for instance, would be upbeat in mood, full of bright, warm colors, high tonal values,

sharp contrasts of light and shadow. But the same scene painted on a cold, blustering day – an empty beach, the wind taunting a lone walker in cape and hat – might have more impact on the viewer. In both cases it is the weather, more than any other factor, which has set the mood of the painting.

It is not surprising, really, that the weather holds such a fascination for us. If you think of a few adjectives used to describe the elements, you will realize that they could equally be used to characterize our fellow human beings, with all their good and bad points: fair, glorious, ethereal, capricious, fickle, warm, temperamental, unpredictable, unreliable, freakish.

For whatever reason, the weather in all its guises provides a tantalizing subject for artists – an inexhaustible supply of ideas which will constantly surprise and inspire you.

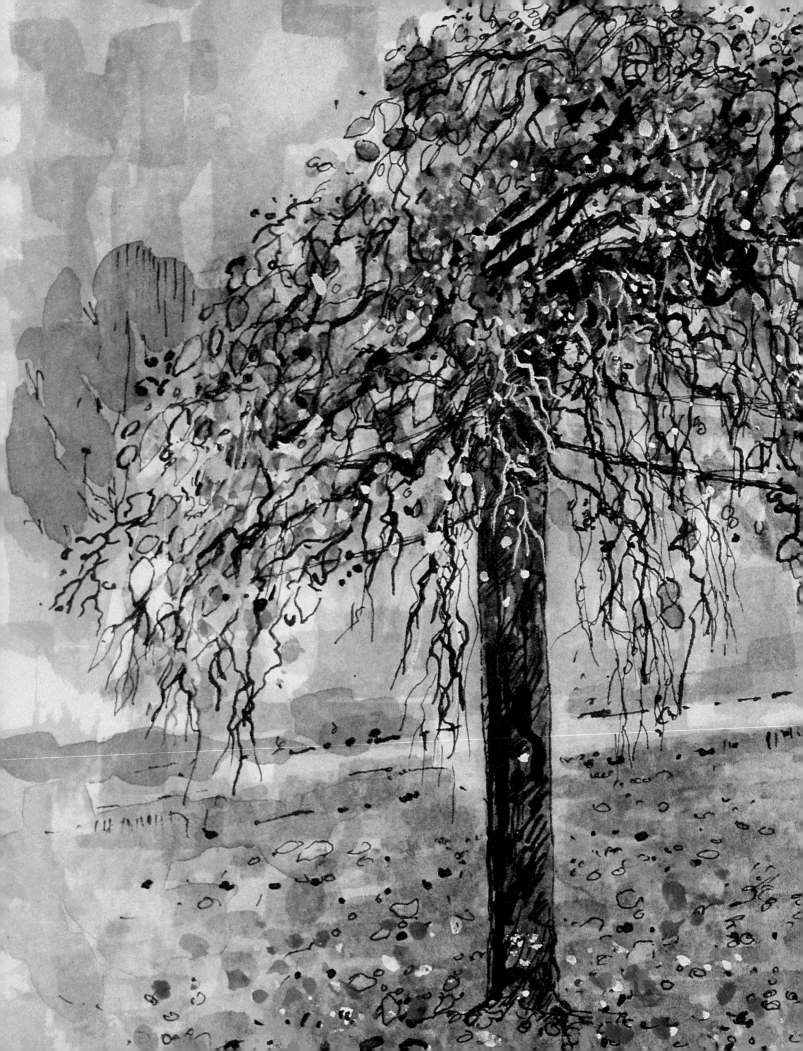

Painting and sketching outdoors

- **What to take**
 Coping with the weather
 Sketching
 Sketching equipment
 Pastels
 Watercolor
 Drying speed of watercolor
 Using body color with watercolor
 Acrylics
 Oils

**A Tree in Autumn,
Bournemouth**, *Ray Evans,
pen and ink, watercolor, and
body color.*
Artists sketching the effects
of weather will interpret the
subject in different ways.
Here, Evans was drawn by
the autumnal weeping tree.
The background is reduced,
therefore, to an abstract
pattern of subtle blue-grays
painted with overlapping
washes.

Ray Evans

There are many approaches to the problem of capturing the elements in paint. Some artists have good visual memories and do not need to have their subject before them in order to characterize it, preferring to work from sketches, photographs, even from imagination. Or they use the elements in a more calculated way, as part of the composition. Others swear that a true representation cannot be achieved without physically braving the storm in order to paint it. Winslow Homer (1836–1910), the distinguished American artist, felt that if you make studies in the open air for use later in the studio "you lose freshness, you miss the subtle and . . . the finer characteristics of the scene itself."

If you are taking up a study of the elements, there is no doubt that the best way to explore them is to get out and record your impressions at first hand. One of the problems of painting weather effects is that they are constantly changing. Spring clouds scamper across the sky in ever-changing patterns, while the progress of the sun during the course of the day can alter remarkably the character of the subject you are painting, as the Impressionists showed us. Sketching and painting outdoors is the best way to understand the fickle nature of the weather and to discover its infinite possibilities for you as an artist.

What to take

Before you set off on a sketching or painting expedition, check that you are properly equipped. Nothing is more frustrating than having to abandon a painting halfway through, never really to be satisfactorily completed, because you have forgotten your favorite brush/burnt sienna/sketchbook, are too hot/cold, you have run out of water/turpentine/insect repellant, or whatever other tragedy can befall the solitary artist.

Obviously, your destination and means of getting there will dictate your equipment. If you have the strength, or are traveling to the site by car, then you can consider taking an easel, campstool, golf umbrella, picnic, or anything else that will improve your comfort.

Sketching and painting in the great outdoors does have its problems — but these are far outweighed by the pleasures

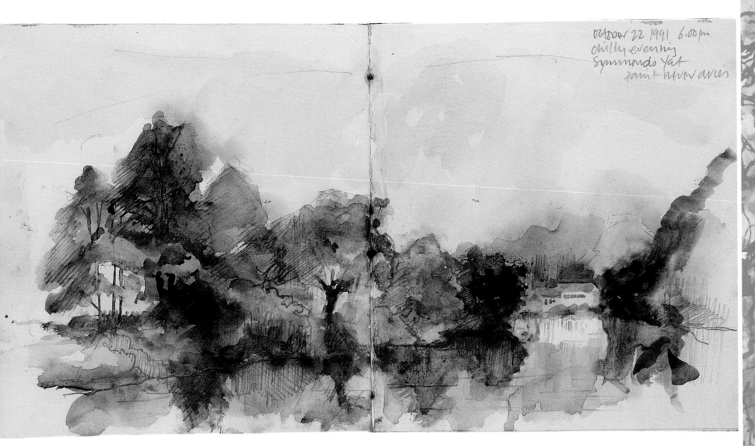

October 22 1991. 6.00 pm
chilly evening
Symmonds Yat
paint never dries

△ **Chilly Evening,**
John Lidzey, pencil and watercolor.
This atmospheric sketch captures the chill of a misty evening in the fall. The artist notes down relevant information for future reference, including the warning "paint never dries." Mapping out form and shade with hatched strokes, he then overlays delicate washes.

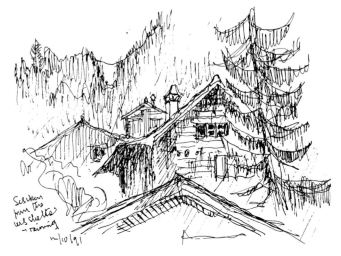

◁ **Sisikon, Lake Lucerne, from the Bus Shelter,**
Ray Evans, technical pen.
You can take a sketchbook with you anywhere. This sketch helped the artist to pass the time while waiting for a bus in the pouring rain.

But if you are trekking out on foot, keep your equipment simple. There is no point in struggling across fields with armfuls of inessential items, only to arrive at the site too exhausted to do any painting. You will find a suggested list of equipment for pastels, watercolor, acrylics, and oils on pages 15–22.

Coping with the weather

The weather in its many forms may be what you are striving to capture on paper, but it is also likely to be the source of problems. Patience and a sense of humor are prerequisites for any artist who paints outdoors, plus the ability to adapt to unexpected changes and use them to advantage rather than being defeated by them. When the wind suddenly whips up on the beach, embedding sand in your painstakingly created, almost completed, oil painting, you could use the experience to experiment with its textural possibilities. (X-rays have revealed grains of sand in the paint in many an Impressionist beach scene!) Have you tried sketching with your hand inside a plastic bag, while raindrops drip off the end of your nose? If nothing else, it can be regarded as a novel experience – and a few raindrops incorporated into a pastel or watercolor sketch can contribute much to the evocation of a stormy landscape.

The sun itself can create heaven or hell for the artist. One of the most annoying problems is that your white paper or canvas can reflect a dazzling brightness which is painful to the eyes and impairs your judgment of values and colors. If possible, work in the shade, or take a tip from those wonderful faded photographs of artists such as Cézanne, Pissarro, and Monet: wear a wide-brimmed hat. It may help, too, particularly if you are working in pastel, acrylic, or oil, to work on tinted paper or a canvas which has been prepared before-

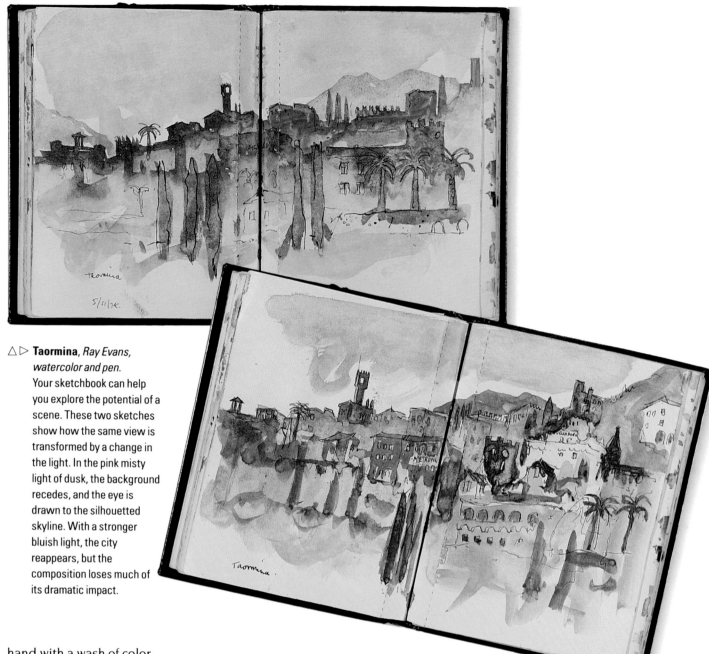

△▷ **Taormina**, *Ray Evans,
watercolor and pen.*
Your sketchbook can help
you explore the potential of a
scene. These two sketches
show how the same view is
transformed by a change in
the light. In the pink misty
light of dusk, the background
recedes, and the eye is
drawn to the silhouetted
skyline. With a stronger
bluish light, the city
reappears, but the
composition loses much of
its dramatic impact.

hand with a wash of color.

The wind can be a problem if it threatens to blow your easel over. To prevent this, attach a piece of string to the easel where the legs meet and suspend a rock found on site to the other end by looping a slip knot around it. An alternative solution is to buy a combined seat and easel with a light aluminum frame, so that your own weight gives stability to the easel.

More commonly, you will be faced with the problem of how to "pin down" those mercurial clouds or that fleeting light effect in your sketch or painting before they disappear. Try to spend 10 minutes absorbing the scene before you start. One of the best ways of capturing the atmosphere and essence of the fast-changing weather is to record it in as many ways as possible in a number of small sketches. Use whatever medium suits you – preferably something that encourages a bold, spontaneous approach. Concentrate on different aspects of the subject in each sketch: the outlines of clouds and their interrelation with other ele-

ments of the composition; tone; color; mood; and so on. In addition, written notes are useful to remind you of certain aspects such as the exact shade of a particular color. You may want to take a polaroid photograph (many artists work from photographs), although it is an ungainly piece of equipment to carry around with you, and some artists find it more satisfying to train their eye to record the information.

Sketching

A sketch is a quick, unelaborate visual note of what you see before you and can be executed in almost any medium – pencil, charcoal, pastels, oils, watercolor, or acrylic, not to mention colored pencils, felt tips, or ballpoint. Try to sketch as often as you can; it will

Kent, *Daphne Casdagli, watercolor.*
With broad strokes and simple coloring, this sketch captures the moment when the sun bursts through storm clouds, with strong diagonal rays cutting across the dark sky. The sketch was mapped out using a large brush on a small piece of paper with no underlying drawing. Suggestions of colored grays have been added to the sky for future reference.

▷ **La Gironde**,
Daphne Casdagli, charcoal, watercolor, and pencil.
This river scene is dominated by heavy, overlapping rain clouds, which Casdagli has built up with a watercolor wash over soft charcoal hatchings, allowing the charcoal to stain the wash. To reinforce the density of the clouds, they have been worked on again with a pencil when dry.

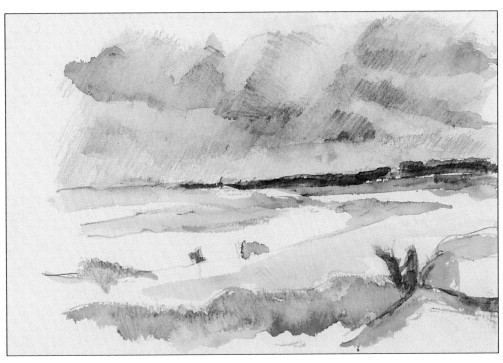

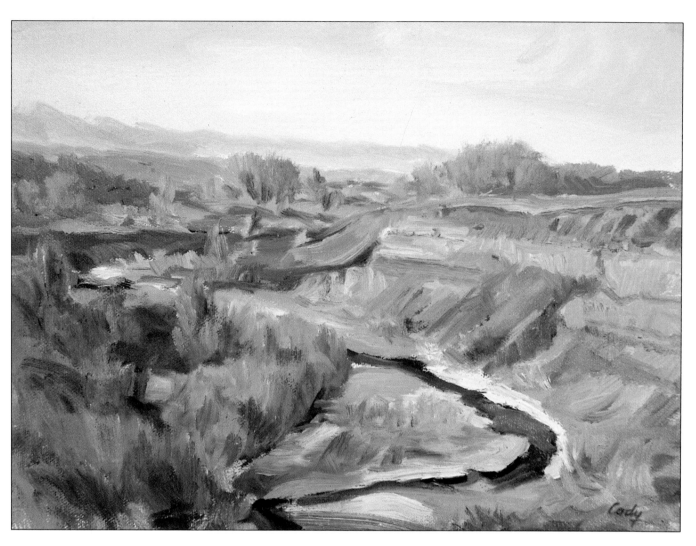

improve your drawing skills, develop your powers of observation, teach you to select the essentials of a scene, and of course provide you with a useful source of material for your finished paintings.

John Constable (1776–1837), regarded as one of the greatest British landscape painters, is an example to any artist trying to capture the effects of weather. Throughout his life he made innumerable sketches of the sky – in pencil, chalk, watercolors, oils. "I have

done a good deal of skying" he wrote to a friend in October 1821. "The sky is the source of light in nature and governs every thing."

When you first set out to study the weather, make a point of sketching in as many different types of weather as possible. Again, Constable gives useful advice. To remind himself of precise weather conditions, he would make detailed notes on the reverse of his cloud studies. For example, "5th of September,

Sketching on Cadier Idris,
Ray Evans, technical pen.
This is what sketching outside is all about: finding the perfect view, with the light just right, and then hurrying to capture it on paper before it all changes. And if the view itself does not captivate your interest, you can always sketch a friend sketching it!

◁ **Plum Creek**, *Bruce Cody, oil.*
This painting was completed
in one session in the *alla
prima* style. Note the
carefully observed subtle
gradations of ochers and
browns, which have been
laid down with confidence,
thus keeping the painting
fresh.

△ ▽ **Outskirts of Benidorm**,
*Mark Baxter, pen and brush,
brown writing ink and wash.*
In the same sketchbook the
artist explores, *above*, the
textures and contrasts of a
hot day with small
expressive strokes and,
below, receding planes with
monochrome washes.

1822. 10 o'clock, morning, looking south-east, brisk
wind at west. Very bright and fresh grey clouds running
fast over a yellow bed, about half way in the sky. Very
appropriate to the Coast at Osmington." This last state-
ment is understood to mean that he thought it appro-
priate for a particular scene which he intended, or had
started, to paint. But it has not been traced.

As to what aspect of the weather you should
choose to record, the answer is all aspects – but not all
at once. Winslow Homer, who liked to paint from life,
wrote: "You must not paint everything you see, you
must wait, and wait patiently until the exceptional, the
wonderful effect or aspect comes." Search out the most
interesting part of, say, the sky – perhaps an area where
there are overlapping cloud shapes or ethereal falls of
light. If it is a windy day, look for something which
expresses it – flapping flags or a particularly pliant
tree. But almost every scene you look at will have such
a "wonderful aspect"; it is simply a case of using your
artist's eye to search it out.

Sketching equipment

All you need to complete an impressive sketch is
some drawing paper and a pencil – preferably a soft
pencil such as a 6B, which produces smooth, strong,
flowing lines. Art paper is available in three different
surfaces: HP (hot-pressed) which is generally too
smooth, NOT (meaning not hot-pressed) which has a
good "tooth," and rough, which is generally too coarse
for pencil drawing.

Charcoal is a highly expressive drawing medium,
ideal for recording fast-changing cloud formations.
Those brittle, spindly willow sticks are to be recom-
mended as they demand to be used gently, relaxing
the hand and encouraging delicate drawing. As charcoal
is sympathetic to the textures and grains of paper,
choose a surface with a pronounced "tooth," such as
watercolor or pastel paper. Because charcoal smudges
easily, it is usually necessary to fix the drawing with a
spray fixative. A couple of light sprays of the fixative
are better than one heavy one.

A sketchbook is easier to carry around than loose
sheets of paper and creates its own firm support on
which to draw and paint. It also makes a better record
of your progress and of information you might need at
a later date: you will find it easier to track down that
"windy day on the river" in a book than in a pile of
loose sketches on paper. A book will also encourage
you to keep your so-called failures as well as those you

regard as your successes. All your sketches will contain information and, as you have probably already discovered, you sometimes change your mind about what constitutes a success or a failure.

A sketchbook does not need to be a large item: it is more convenient if it can be carried in your pocket or bag. Constable in 1819 recorded information in a Lilliputian sketchbook about the size of a credit card. A small sketchbook will fit in your pocket and, especially if used with a soft pencil or charcoal, will force you to concentrate on general shapes and areas of dark or light, without getting bogged down in detail. But a slightly larger sketchbook is more usual and generally more useful: 7 × 10in. (19 × 24cm) is a good size.

Pastels

Simple to use yet highly expressive, pastels are a marvelous medium for catching an image rapidly. Highly versatile, they can be used for rapid sketches or fully developed works, for creating delicate lines or broad, painterly strokes. In fact, pastels are unique in being both a drawing and a painting medium.

If you've never used pastels before, start off by restricting yourself to using just black and white. This will give you some interesting tonal insights, particularly if you use a tinted paper, without being confused by too many competing colors. Then move on to experiment with color mixing on paper, using some of the techniques suggested on these pages.

Artists who work in oils often find that sketches made on location in pastels are more useful to them as reference than, say, those made in watercolor. This may be because oils and pastels have similar qualities – they are both opaque and both can be softly blended or applied in a rapid, *alla prima* manner.

Pastel equipment is conveniently light and portable for outdoor work. The range of pastel colors you take will depend very much on the climate in which you are working and your subject matter, but because they are so light and compact, it is easy enough to

carry a broad selection. Pastels come in a vast choice of colours because each one is available in a variety of tints from 0 (highly tinted with white) to 6 (most saturated). For painting landscapes and weather effects, you will find the most useful colors are the subtle grays, greens, ochers, and pinks, supplemented by one or two bright primaries.

Tinted pastel paper is ideal for outdoor work, since you will be working quickly and you can incorporate the color of the paper into your composition. Pale blue and gray are particularly useful in establishing the middle tone for skies. The rough side of ordinary brown wrapping paper works well and provides a pleasing warm undertone for landscape work. The most common pastel papers are Ingres, Canson, sugar paper, velour, sandgrained, and tinted watercolor paper. Each of these has a different surface texture, ranging from rough to smooth and velvety. Which you choose depends on the kind of marks you want to make and how much you plan to blend the colors, and it is worth experimenting to find out which surface works best for you.

If you don't wish to use an easel, try a light piece of board – plywood or Masonite – small enough so that it can be rested on your knee, and use clips or tape to secure the paper to the board.

Most pastel drawings need to be fixed when completed to prevent the powdery pigment from smudging. Always spray with care – a few light coats are

Terriers in the Sun,
Daphne Casdagli, oil pastel.
Strong tonal contrasts and warm colors help to express the heat of the sun, enjoyed by these basking terriers. The image was worked up on coarse-grained paper; the artist blended the colors on the paper and then scraped back in places to reveal the colored ground.

better than one saturating layer. Some artists refuse to use fixative at all, finding that it not only darkens the color of the pastels, but also hardens the surface, spoiling the soft, chalky appearance which is so attractive. You can compromise and fix the underlayers, leaving the final one fresh and tactile. Unfixed pastels will survive, but the surface will come away on everything it touches, so store them away carefully between sheets of tissue paper or have them framed behind glass as soon as possible.

1 Working from light to dark, the artist locates areas of highlight. You will need to concentrate hard to see these highlights as two-dimensional patterns within the interlocking jigsaw of tones which makes up the landscape.

2 After exploring the darker mid-tone grays, further subtle mid tones are created as in the foreground, by lightly running the flat side of the pastel over the textured paper so that the dark gray color shows through. Similarly, the sky is worked with irregular directional strokes of broken tone.

3 Finally, the darkest shade is added to the tree and in small patches overall. The highlights are then reassessed, and touches of pure white are applied with pressure so that the paper is occluded.

TONAL STUDY
With snow scenes the presence of the reflected light and color can affect your judgement of tonal values. To help you to see the tones more clearly, try making a sketch in monochrome using pastels, restricting yourself to a light and a dark and two grays in between. Here, a dark gray tinted paper acts as the darker mid tone. Choose a simple subject, and try not to cheat by sketching in the outline first.

▷ **Snow Scene**,
Clarice Collings, watercolor.
The texture of this dramatic
sky can be contrived by
sprinkling salt into a damp
watercolor wash. The results
can be varied by controlling
the length of time the salt is
left on the drying paint
before brushing it off, and
also by the size of the salt
crystals used.

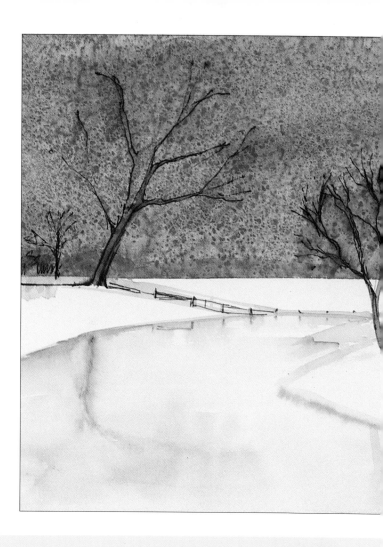

Watercolor

The delicate translucence of watercolor lends itself
perfectly to reproducing weather effects – amorphous
summer clouds, the ethereal beauty of early morning
mists, windy beaches, sun-filled arbors, or winter's
cold light. It is the traditional medium of the landscape
painter. Anyone who has used this medium, however,
will be familiar with the fact that it does not take to
being reworked or pushed around. It encourages a
spontaneous approach which is particularly suited to

**Claude Monet Painting at the
Edge of a Wood**, *John Singer
Sargent, oil on canvas,
117 × 143in (53 × 65cm),
Tate Gallery, London.*
Sargent's painting of his friend
Monet tells us as much about
Monet's *plein air* painting
methods as about his own. Here
we see Monet on a bright,
overcast day absorbed in his
work, oblivious to everything
else. Monet would paint
outdoors for many hours at a
time, and here we see him
seated comfortably on a stool,
wearing a brimmed hat to protect
him from the sun and reduce the
glare from his canvas. Sargent
conjures up for us the speed at
which Monet is working and the
broad, free brushwork of his
painting. Sargent's own painting
is more like an oil sketch,
completed with quick, deft
strokes of mainly dilute paint.

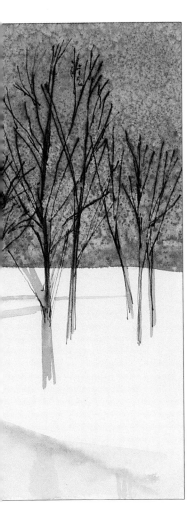

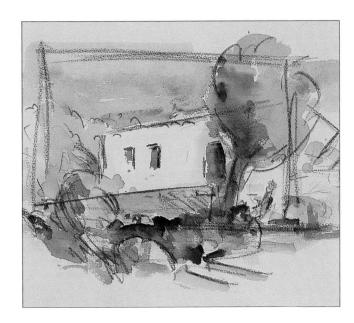

▷ **The Little House in Umbria,**
David Holmes, watercolor and crayons.
A quick watercolor sketch painted without a pencil guide explores the potential of this sunfilled scene. Watercolors dry quickly in hot conditions, allowing the artist to consolidate forms and details with overlaid marks in crayon – as on the roof tiles and the seated figure. Finally he marks off the area which he considers would make the best composition for a painting to be completed later.

▽ **Medellin,** *Daphne Casdagli, pen and brown ink and watercolor.*
Dark rain clouds hang over rich tropical vegetation. The notes remind the artist of the "variety of greens" which have been recorded in washes applied wet-in-wet and blotted with a tissue.

sketching. Yet a finished painting need only take an hour or so.

Watercolor equipment is tailor made for painting outside – light and easy to carry. All you need to take are your paints, brushes, a water pot, a plastic bottle of water, a watercolor pad, a pencil, and a cloth. A box of dry pan paints will be lighter than tubes, and the inside of the lid provides a surface for mixing. If you are using a sketchbook, make sure the paper is thick enough to take a wash. A paper of anything less than 140lb. (300g/m²) will buckle irredeemably when wet washes are applied.

Drying speed of watercolor

Whatever the weather, anticipating the drying speed of your watercolors is the crucial thing. You need to plan a watercolor before you start, mapping out in your mind, or with a pencil, those areas of highlight which you intend to leave unpainted. Think, too, about where there are likely to be fusions of colors painted wet-in-wet, and where there will be crisp areas, built up with overlapping washes.

The main problem with using watercolor in the open air is that the drying speed can be greatly affected by the ambient temperature and humidity. On a really hot day, the paint dries almost before the brush has left the paper, leaving the paint gritty. You need to mix plenty of paint and, to hold it, use a larger brush than

usual or a sponge for washes. You may find it easier to work on a smaller sheet of paper, as extensive washes are difficult to carry out in very hot weather.

On a humid day, on the other hand, washes take forever to dry, testing your patience and invariably causing colors to run together when they were meant to stay apart. But watercolor painting has everything to do with exploiting accident and chance. However much you plan, you will always be faced with the unforeseen backrun or splodge that has to be made to play a positive part in your painting.

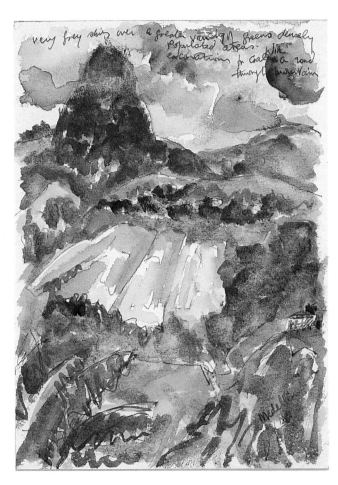

1 The sea and sky are painted with a mixture of ultramarine and white, undiluted. The colors are worked wet-in-wet and only partially blended.

2 Now the artist tackles the palm vegetation, working quickly from dark to light.

3 Now the contrasts are worked up: hints of cloud in the sky, highlight touches on the headland, waves near the shore, and dappled sunlight on the palm trunks.

USING ACRYLICS FOR SKETCHING

Acrylics are a useful sketching medium because they can be used in so many different ways – diluted like watercolors, or thickly like oils. In this project the paint is used almost undiluted, in a manner more usually associated with oils; superimposed layers of paint are built up from dark to light.

Using body color with watercolor

Transparent watercolor can be mixed with opaque Chinese white to give the colors an attractive semi-opaque, slightly milky quality. Subtle touches of body color can be used alongside pure watercolor to produce hazy atmospheric effects such as mist or falling snow, or to paint the creamy highlights on sunlit clouds. To a certain extent, using body color allows you to paint light colors over dark, or to correct mistakes. It is particularly effective when used on toned paper which is allowed to show through the overlaid colors in places.

Acrylics

Because there is no tradition associated with using acrylics for outdoor painting, they are not the most obvious choice. Yet they are very practical for the purpose as they are so versatile. Diluted heavily with water, they can be used like watercolor, either on canvas or on paper; used neat or almost neat, they produce impasto effects more usually associated with oils. This is useful if you want to experiment with different techniques when out sketching, without having to take a string of pack ponies to carry all your equipment. All you need is a select number of tubes and brushes, some paper or a canvas board, a palette, a container of

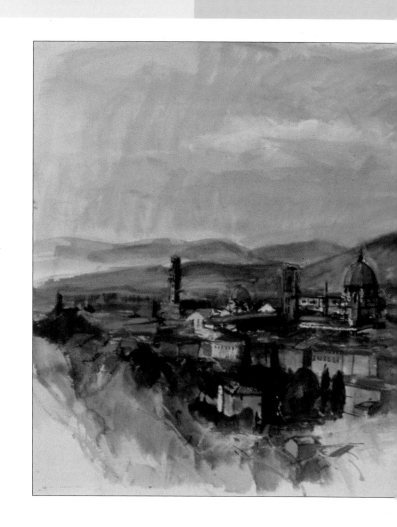

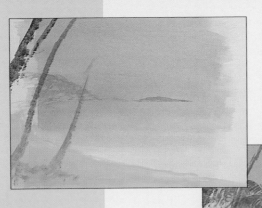

1 Diluting the paint with water will produce a thin mix suitable for a wash. The artist has quickly brushed on the initial wash of blue with a large flat brush.

2 Building up the date palms, the leaves are added on the top of the pale blue wash. The artist is feeling for an impression which he will later work up in the studio.

USING ACRYLICS DILUTED
Acrylics can be diluted with water or medium and used rather like watercolor or gouache. Obviously, the paint does not behave in precisely the same manner, but it is similar enough to enable you to explore the possibilities of a scene. Acrylics used in this way are suitable for all the techniques associated with watercolor painting – washes, wet-in-wet, lifting out, and so on.

3 Final touches in the finished sketch include more superimposed washes in the sea to explore possibilities for enlivening the area.

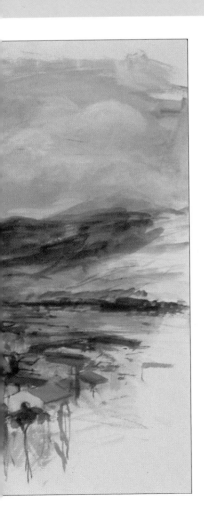

Florence, *David Carr, gouache.* Working with gouache over a brown chalk sketch, the artist produces an unusual view of Florence. The values are keyed low because the sun is still behind the distant hills. The sky adds to the composition and is built up from overlapping washes of color – pink, grays, and then blue which is almost scrubbed on. The opaque gouache allows touches of ocher-white to be added to the clouds at the end.

water, and a cloth. Acrylics work well on heavy paper, though if the paper is very absorbent, the first application of dilute pigment will sink into the paper (which creates an interesting effect). Paper plates or foil food containers work well as palettes and are light to carry.

Acrylics dry very fast in normal conditions; on a hot day, they dry even faster, which makes it difficult to manipulate them on the support or even to keep them manageable on the palette. A transparent substance called a retarder can be added to the paint so that it dries more slowly, but it loses its efficacy if the colors are diluted with a lot of water, so most artists learn to do without it in the end. But the speed of drying can be an advantage, as it enables successive layers to be applied without having to wait long between stages. Also, unlike oils, your painting will be dry enough to carry home without any fear of ruining it.

Any artist bent on capturing the cool blues of a snow scene *en plein air* should be aware that, in extremely cold temperatures, the chemical combination of acrylic paint is destroyed, and the colors will not last.

Malta Landscape,
Peter Clossick, oil.
Using oil paints in this fresh, direct way, a painting can be completed in a single session. The paint here has been applied thickly in bold horizontal strokes, creating an almost abstract pattern of color from the landscape. By progressively reducing the strength of color and shades toward the horizon, a sense of receding space is established. The subtle pink and blue grays are reflected in the sky, unifying the painting.

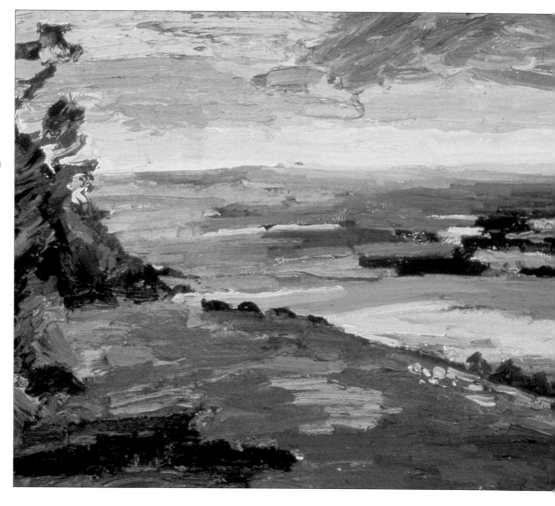

1 On a sheet of prepared oil sketching paper, the artist maps out the areas of dark shades in the landscape. Any mistakes can be rectified by wiping with a cloth and a little turpentine.

2 Working into and around the darker areas, shades of yellow and green are applied with broad strokes, using a flat brush. The artist is beginning to establish the pattern of lights and darks created by the sunlight shining through the clouds.

3 Sketching in the clouds wet-in-wet, touches of ocher are added. The landscape is reworked to incorporate an area of sunlight. White is brushed unevenly into the yellow.

BLENDING: OILS
Oil paints remain wet for hours, allowing you to move them around, blend in new colors, or generally change your mind. This makes oils perfect for sketching changing weather conditions. However, if the painting is to appear fresh, it must not be overworked. Here, on a breezy summer's day with racing clouds casting ever-changing shadows, the artist has been able to work out the best solution.

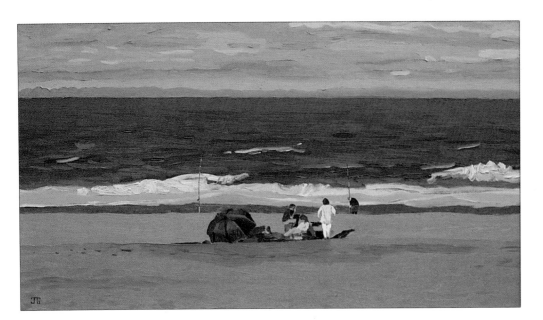

Cley Beach on a Blustery Day, *Jeremy Galton, oil.* Cley Beach has been painted by this artist countless times and in every kind of weather, but still it fires his imagination. Here, bright light coming from behind the artist has produced high contrasts. Painted *alla prima*, the deep violet-blue of the sea is set against the rich white of the impasto surf. On this breezy day, it is the sea which dominates the painting.

Oils

Oil paints are still regarded by many as the best medium for capturing the fleeting effects of changing weather conditions. The paint stays wet for a long time and so can be reworked and added to until a solution is reached, and an infinite variety of textures and effects is possible. Depending on your subject and how you prefer to work, you can either build up the image slowly with successive layers of thin color, or you can complete it in a single session using the *alla prima* technique. With this approach the paint is applied more thickly and is handled freely and spontaneously, often using several techniques, such as blending, impasto, and scumbling, in one painting.

Of course, there are disadvantages in the slow-drying nature of oils, as anyone will know who has tried to walk home carrying a wet oil painting. Everyone has their own solution to this problem, but the simplest if you are painting on stretched canvas is to tie two canvases together, face in, with wooden spacers top and bottom separating the wet surfaces.

Equipment for outdoor painting in oils is a little more complex than for most other media. Apart from a portable easel, you will also need to take perhaps 10–12 tubes of paint, a selection of bristle and soft-hair brushes in a choice of sizes, stretched canvas or canvas board, a palette, linseed oil and turpentine and something to mix them in, sticks of charcoal, and rags for cleaning. Of course, if you are only sketching you can get by with much less, and you will find a pad of specially prepared oil sketching paper very handy.

Cley Beach on a Fine Day, *Jeremy Galton, oil.* On a fine day, the same beach takes on a different aspect. Now the light is weaker, raking in from the left and producing long shadows. For the clear blue sky, shades of blue are blended together in horizontal bands. The raised imprint of the brush in the paint catches the light, adding a further dimension. This sky blue is taken down and worked wet-in-wet into the dark sea color, which in turn is worked into the sand.

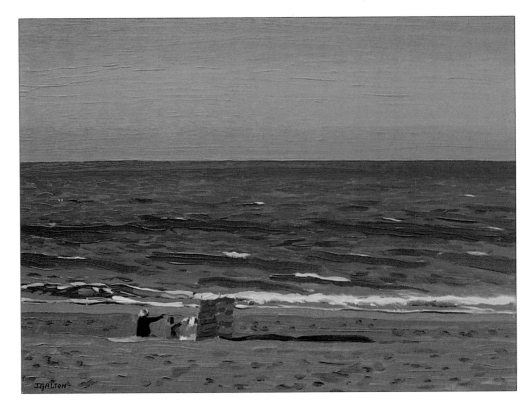

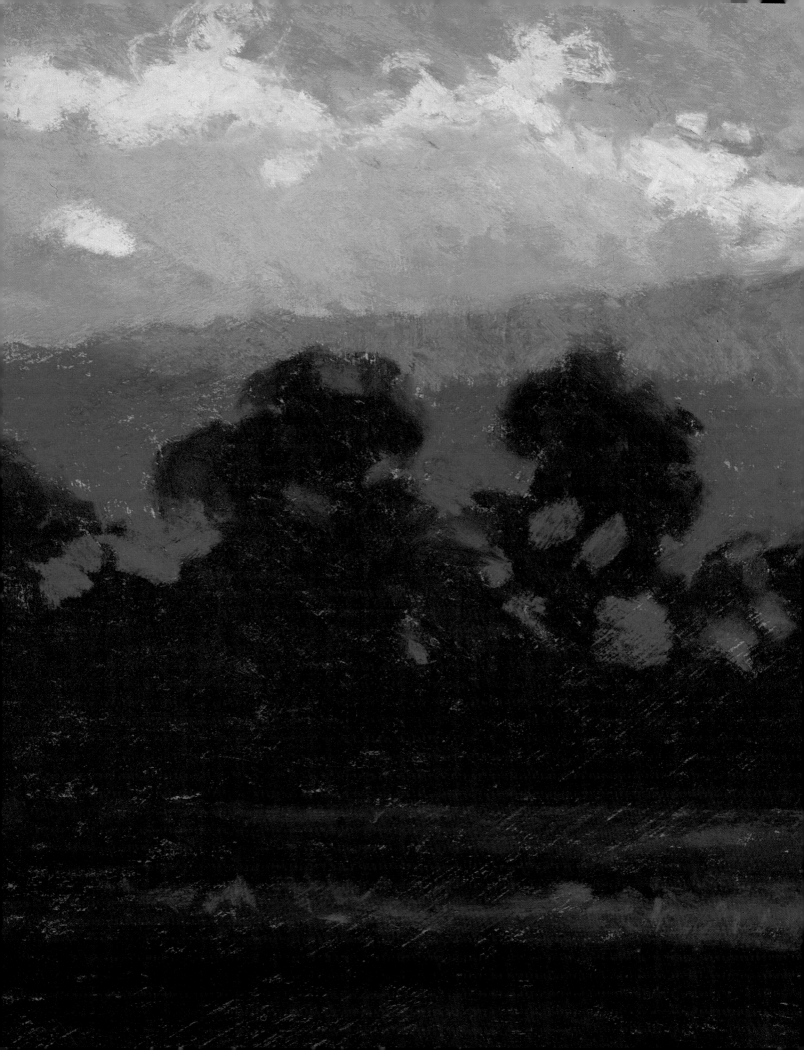

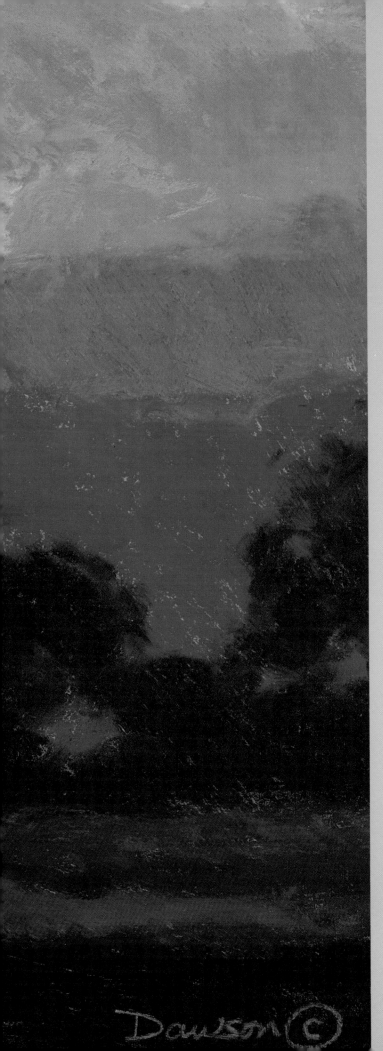

Clouds

- **What are clouds?**
 Observing clouds
 Types of cloud
 Cloud outlines
 Light and clouds
 Cloud color
 Palettes for fair-weather clouds
 Demonstration: fair-weather clouds
 Cloud highlights
 Complementary colors in clouds
 Techniques for painting clouds
 In focus: luminous clouds
 Sunsets and clouds
 Composing with clouds
 How to achieve depth in your skies
 Integrating sky and landscape
 Creating mood with clouds

Sky over Morrison,
Doug Dawson, pastel.
In the fading light, the
landscape is reduced to
bands of dark color and
silhouetted trees, leaving the
sky to play the lead part. Yet
the artist is not carried away
by garish sunset colors,
only hinting at their
magnificence. Dawson gives
movement to the clouds by
keeping them soft-edged
and avoiding hard outlines.

louds are a captivating subject for any artist. Sometimes fresh and sprightly, sometimes amorphous, other times dark and brooding, you can never tire of the moving picture show they provide. No wonder we feel that the sky and the weather affect us all so much.

Apart from their natural beauty, clouds have exciting shapes which can be useful in strengthening the composition of your painting. You can also manipulate the atmosphere and mood of your work through clouds. For example, most people think of storm clouds as dramatic and foreboding: including them will automatically trigger this reaction, thereby setting the mood for the rest of the painting, whether it be a dark alley or a winter seascape.

It is not common for clouds to be the sole subject of a painting, but a cloudy sky is sometimes used as the focal point of a landscape composition. However much or little of the sky is included, it must be seen as a positive and influential part of the scene. That is why it is sad to see a cloudscape reduced to a trite formula, simply tacked on to the landscape. Even if you think you know about clouds, make studies of them as often

To be able to paint a good landscape, you need to know how to paint a good sky

as you can – or just watch them. You will learn something every time. Turn to the next page to get an idea of the variety of clouds which fill skies every day.

Many people find clouds difficult to capture in paint – they have a habit of changing shape or even disappearing before you've barely had a chance to put brush to canvas, or they end up looking lumpy and solid instead of hazy and atmospheric. To help overcome these problems, in this chapter we will explore clouds in detail. First we will learn to recognize and record their physical shapes, then we will look at useful techniques for painting clouds in various painting and drawing media.

What are clouds?

Many successful artists will emphasize the need to be intuitive and not too literal with the painting of clouds. But it helps to know the facts about clouds so that you have the confidence to be intuitive. Clouds collect in the sky when rising air carrying invisible water vapor expands and cools in the upper atmosphere. This cooling causes the water vapor to condense into countless water droplets, which eventually expand and join together to form clouds. The droplets may fall from the cloud as rain, hail, sleet, or snow.

(Continued on page 30.)

△ **View of San Giorgio Maggiore, Venice,**
Milton Meyer, pastel.
Here low-lying stratus clouds are given an amorphous quality by smoothly blending the delicate grays and blues.

◁ **Vermont Sky No 3**,
Beverley Ferguson Deevy, pastel.
In this cloud study, the artist concentrates on the pattern made by the dark clouds, the highlights, and the gaps between the clouds.

▷ **Beach of St. Restitude, Corsica,**
Barry Freeman, oil.
Low-lying cumulus clouds are painted broadly and intuitively, giving the impression that they are moving across the sky.

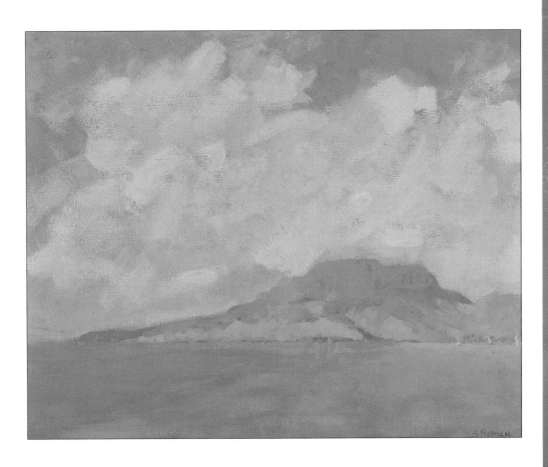

Cloud studies

Studying clouds is no hardship: their diversity can only delight the artist. These photographs suggest how the ingenious painter could use clouds in his or her work.

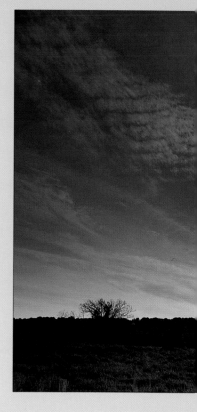

▽ The sky is often filled with different clouds at various levels. Here there are low cumulus clouds with vaporous cirrus above. In watercolor these clouds could be lifted off a blue wash, varying the pressure of the dabbing according to the density of the cloud.

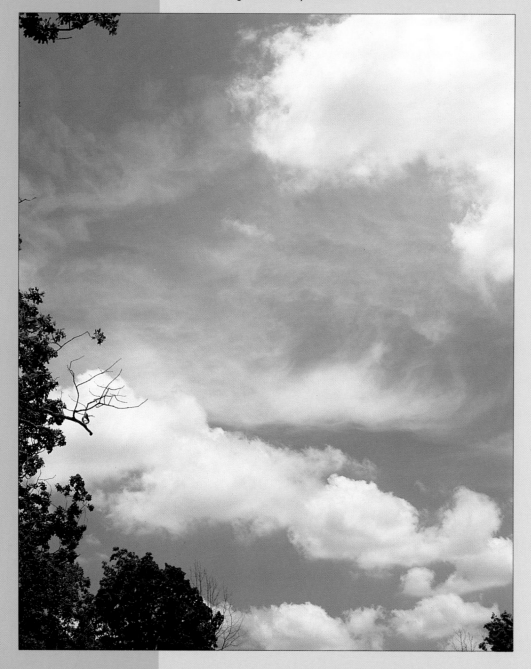

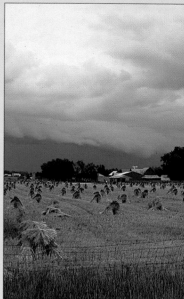

△ Storm clouds massing above this peaceful scene create an almost surreal contrast. The sun breaking through the clouds in the top left-hand corner would make a suitable focal point.

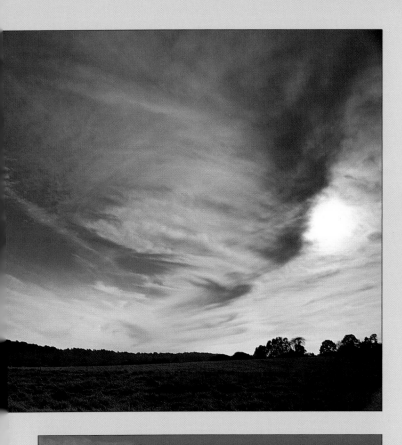

◁ An extraordinary confluence of clouds often occurs at sundown. This would be a perfect subject for soft pastels and their delicate blending effects. But remember that subtle colors are often lost in the photographic process. It is in replacing these that an artist's own experience is useful.

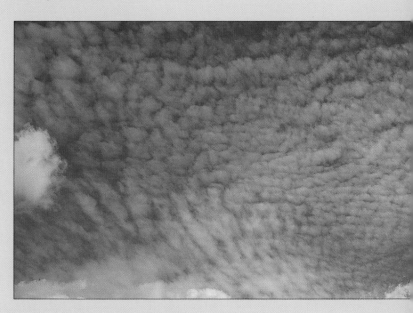

△ This summer sky shows a mottled form of cirrus. John Ruskin remarked on the peculiar symmetry of such clouds. Such an effect could be created in oils or acrylics with dry brush or scumbling techniques.

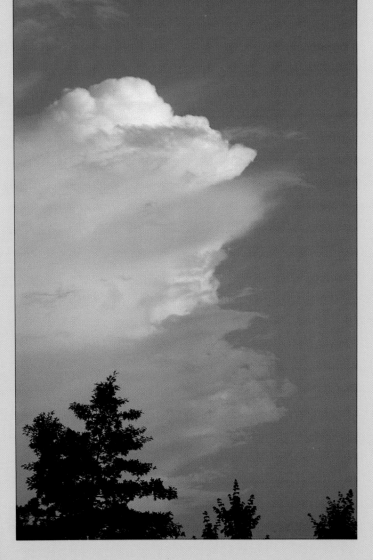

◁ A massive white cumulus raincloud proceeds across the sky, partly masked by yellowish whipped-up stratus. The outline defies invention, and, in its asymmetry, it would make an unconventional composition.

▽ Viewed from above, these banks of low-lying clouds are seen in high contrast in the foreground, diminishing with distance. Their soft, vaporous tops are tinged with the palest pinks and yellows by the rising sun.

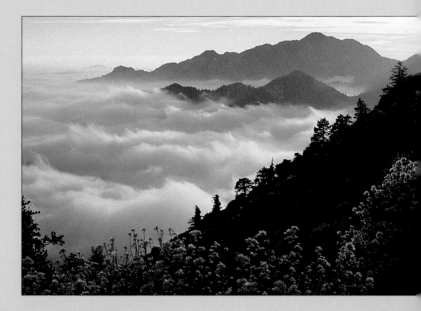

Grimstone Down, Dorset,
Ronald Jesty, watercolor.
Sensitive to pattern in nature, Jesty builds up the low-lying summer stratus clouds with carefully placed washes superimposed wet-on-dry. Softer edges are created by applying a light color over a darker one, as with the gray over the deep blue in the top left corner. This also knits the cloud area into the small patches of blue sky, which have a habit of coming forward in the picture plane if not well integrated.

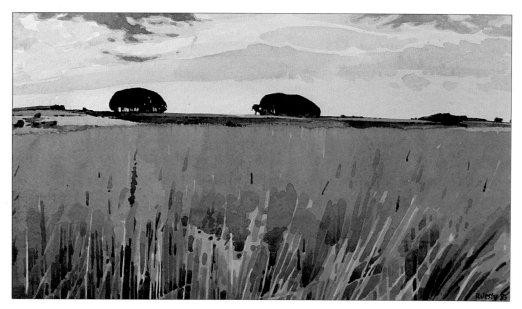

Types of cloud

Perhaps you would prefer not to know about such scientific facts and would rather just use your eyes to record what you see. But skies are often a mixture of different types of cloud ranged at different levels, and it helps if you can identify them and treat them according to their nature.

Types of cloud formation are the result of differ-ent directions of air movement and variations in air pressure. There are three main types of cloud – cumulus (low, heaped), stratus (low, layered), and cirrus (high, vaporous). Middle-level clouds are prefixed with "alto" (hence altocumulus) and high level clouds with "cirro" (cirrostratus).

● Cumulus: These are the great, billowing, heavy clouds at a low level, which change their shape like a mutating being as they are blown across the sky.

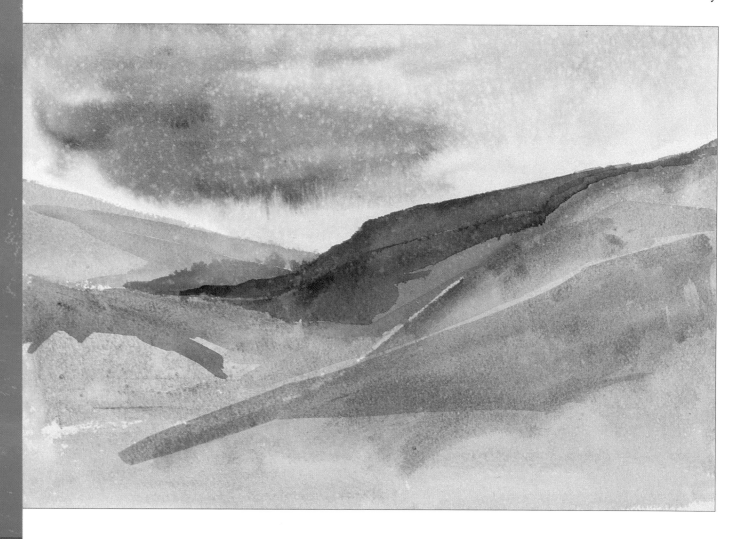

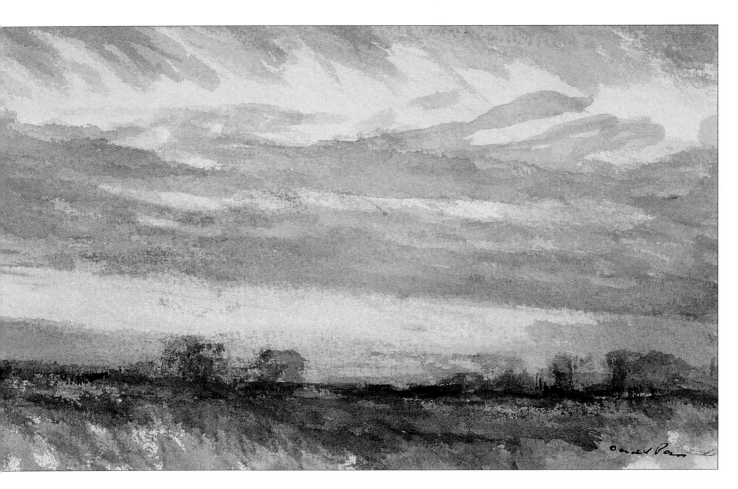

◁ **Sketch from a series of 11 paintings**, *Clarice Collings, watercolor.*
Painting this headland in many different weather conditions has given the artist an insight into the effects of weather on the landscape. On this occasion, low-lying dark rain clouds push back the distant hills and throw up the headland into silhouette. The impression of falling rain is given by the blurred edges of the clouds, painted wet-in-wet into the surrounding wash. The sky area is then textured by sprinkling it with salt; when the wash is dry, the salt is brushed off and leaves a spattered effect, suggesting wind-blown rain.

Winter Dusk, *Donald Pass, watercolor.*
Banks of low-lying cumulus clouds are lit from beneath by the setting sun. Working when the light is fading fast means working quickly, establishing first those aspects which are changing. Here, the areas of light and dark were mapped out with subtle washes. Then the scene was built up with superimposed washes wet-on-dry, with drybrush and scumbling techniques used to add texture and detail.

Cumulus have more three-dimensional mass than other clouds, particularly when they are lit from behind by the sun. These are the clouds most often seen in landscape paintings, perhaps because their heaped forms are a natural complement to the shapes of trees and hills in the landscape below, helping to integrate the composition.

Layers of low cumulus clouds, either broken or covering the whole sky, are described as stratocumulus. Heavy storm clouds towering high into the air are called cumulonimbus.

A "mackerel" sky, so-called because its dappled and rippled appearance resembles the markings on the fish, is a middle-level altocumulus, which also includes among its disguises broken, disordered, storm clouds (floccus).

● Stratus: These are low layers of amorphous cloud, through which the sun can be seen sometimes breaking. Contrasts of tone are low on days with such clouds, accentuating the delicate middle tones. Nimbostratus clouds are similar, but more dense, and are associated with bad weather.

Altostratus lie mid-level in light layers, allowing a watery sun to shine through weakly. A halo around the sun is caused by a vaporous, almost invisible layer of cloud high in the sky, called cirrostratus.

● Cirrus: The high, wispy clouds of a summer's day, sometimes called "mare's tail." Cirrus clouds have no mass as such and therefore do not reflect much light. They usually appear as streaked white trails across a blue sky.

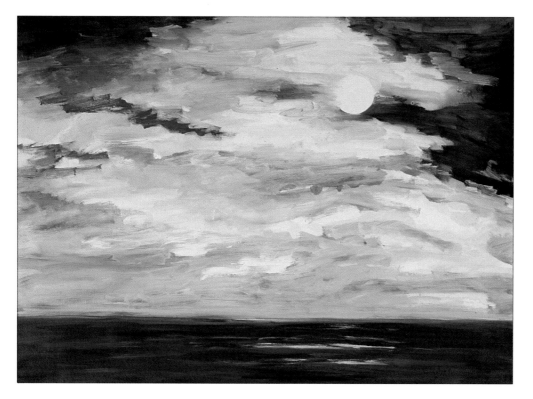

Moon Clouds,
Joyce Wisdom, oil on paper.
Moonlight is generally a cool, whitish light with little strength. Here the clouds pass over the moon, lit up by its ghostly light. Shades of deep violet blue are worked over wet-in-wet with whiter mixes, scumbling and blending to produce a dramatic night sky.

Cloud outlines

Having looked at the classification of the different types of clouds, it is time to study the clouds themselves at first hand. Not just other people's impressions of clouds but real clouds – the ones you find outdoors. In the mid-nineteenth century the painter and art critic John Ruskin (1819–1900) berated the painters of his time (except Turner, whom he eulogized) in his three-volume study *Modern Painters*. Volume I, Section III, is entitled "Of Truth of Skies." Here he moans that contemporary painters make their clouds up from repetitive convex curves, whereas anyone who looks at clouds will know that they are never so monotonous. "First comes a concave line, then a convex one, then an angular jag breaking off into spray, then a downright straight line, then a curve again, then a deep gap, and a place where all is lost and melted away, and so on." This is what clouds are like if you really look at them, and it explains why painting them can become an obsession. Clouds are a constant source of entertainment for the artist – they are never the same, not from any point of view.

Light and clouds

When drawing or painting clouds, bear in mind what Constable said about the sky being the source of all light. Even where clouds obscure the sun, light still shines through them. Before you begin painting a cloudy sky, work out the position of the sun. It is crucial to determine your light source early on, and maintain it consistently throughout the painting, because as you work, the sky is constantly changing due to the shifting position of the sun.

At noon, with the sun high in the sky, the tops of

To learn how to model cloud formations on your canvas or paper, pick if possible a single but interesting heap cloud to study. With a large round brush full of very dilute Payne's gray watercolor, try locating the pattern made by the shadowed part of the cloud (you will find this easier if you squint your eyes a little). Try not to think of the cloud as a three-dimensional mass, but simply as a two-dimensional arrangement of light and dark. Let the brush tip describe the contours of the shadow, while the belly of the brush fills in the shadow. Next, in a new study, mix two shades of gray, still well diluted, one darker than the other. Now try isolating first the middle tones, then the darker tones, from the white highlights of your cloud.

You may find this easier with black and white pastels (or charcoal and white chalk) for the light and dark tones, working on tinted gray paper to represent the middle shades.

This exercise will take some practise, but you will be on your way to producing believable clouds.

1 A heavy gray sky is built up with colored grays mixed from ultramarine, cadmium red, raw umber, and white in varying proportions, and the cloud shapes are roughly mapped out.

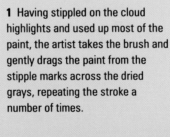

2 Using a flat bristle brush loaded with white with a touch of yellow ocher, the undiluted paint is stippled on with a gentle jabbing motion, sometimes leaving the imprint of the brush clearly visible, other times spreading the paint.

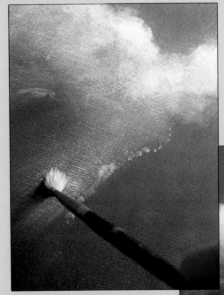

3 The precise mark made depends on the amount of paint on the brush and also on the amount of pressure exerted. With this simple technique the artist has given an impression of sunlight shining through the vaporous edge of the cloud.

STIPPLING

This is a technique in which shades, colors, and textures are built up methodically in a series of fine dots applied with the point of the brush. Gradations of shade are achieved by varying the density of the dots. Any medium can be used, though this demonstration uses oils. Stippling can be done on white paper or on top of a dry wash, and wonderfully subtle effects are obtained by intermixing two or more colors. To stipple, hold the brush at a right angle to the support and apply a gentle jabbing motion without pressing too hard. Paint for stippling should be "dry" rather than runny. Generally, a small, well-pointed soft brush is used for stippling, but you can also use a large bristle brush or even a decorator's brush; each of the stiff bristles leaves a tiny dot of color, so a large area can be covered more quickly.

1 Having stippled on the cloud highlights and used up most of the paint, the artist takes the brush and gently drags the paint from the stipple marks across the dried grays, repeating the stroke a number of times.

2 This drybrush work gives the impression of light shining through the cloud.

DRYBRUSH

As its name implies, the drybrush technique means painting with a dry brush and only a little undiluted paint on a dry surface. The oil or acrylic paint is dragged lightly across the paper or canvas so that it only partially adheres, leaving a broken-textured stroke with the underlying color showing through. When painting clouds, this is a useful technique for expressing light shining through vapor, or shafts of light piercing through the gaps between clouds.

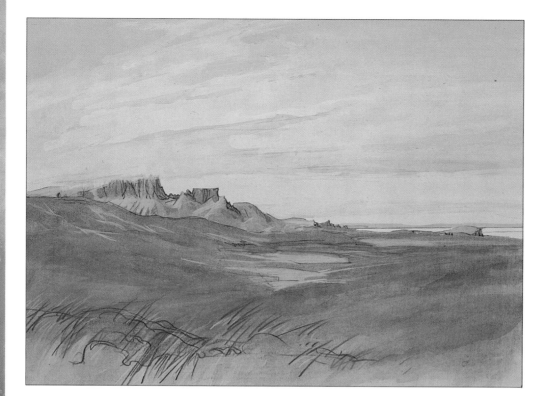

Project ●

the clouds reflect light while the undersides are in shadow. You will notice that the sunlit tops of the clouds have a hard edge, while those parts in shadow have a softer outline.

Even though heavy clouds have a mass of sorts, they are not rounded like a ball of cotton. You will find each cloud is different, made up of an unpredictable, uneven mass of crags and eddies which reflect the light in different strengths. Yes, look at these patterns of light and shade and record their diversity, but, no, you cannot be too literal about them. You will need to develop your intuition; otherwise, the clouds will become too static.

Cloud color

It is easy to think of clouds as simply gray and white, but if you look at them carefully, you will be surprised by the variety of colors they contain: the "white" areas may contain hints of pink, yellow, and blue, and the gray areas may appear purplish or brownish.

You will find that your clouds will gain a new vitality and luminosity if painted with delicately "colored" grays. For a start, reject black and try instead a mixture of ultramarine and burnt umber, or ultramarine and alizarin crimson as your darkening agent. Add white or water, depending on the medium, to lighten the color, and a touch of yellow ocher, raw sienna, or cadmium red for pink or yellow grays. You will find these mixes for grays more lively: adding straight black or white reduces the intensity of the mixture and produces a lack-luster, often muddy gray.

Payne's gray is a very useful ready-mixed gray which is both a yellow and a pink gray. Once you have experimented with mixing grays, you will find that
(*Continued on page 38.*)

The Quiraing, Trotternish, Isle of Skye, *Mark Hudson, gouache and crayon.*
The position of the sun in this painting is up to the left. The light is tempered by the hazy summer clouds, which have no mass as such and therefore do not reflect light to the same degree as more solid cumulus or stratus clouds. These wispy clouds are suggested with broken washes of very pale blue, yellow, and white over a brownish toned ground. When the paint is dry, colored crayons are used to add delicate shadows under the clouds.

Try sketching the outlines of clouds, disregarding any attempt to model or color them. You will soon see how true Ruskin's words are about their unexpected outlines and how you have been brainwashed like everyone else into "seeing" clouds as a shape made up of convex curves. Even if you only sketch for five or ten minutes a day from your window, you will soon assemble an encyclopedia of cloud shapes which provides a valuable reference source for your full-scale paintings. You will also find your line will gain in assurance: your eye will learn what to look for and your hand will respond with greater facility.

● WATERCOLOR

Cerulean is a good blue, particularly for a summer sky. The artist has encouraged it to be retained in the dips of the rough paper. Note the sharp edge painted around the highlit top edge of the cloud. The shadows are created by merging colored gray washes wet-in-wet; touches of raw sienna, Payne's gray, and cobalt blue are visible. Further darker grays are added wet-on-dry.

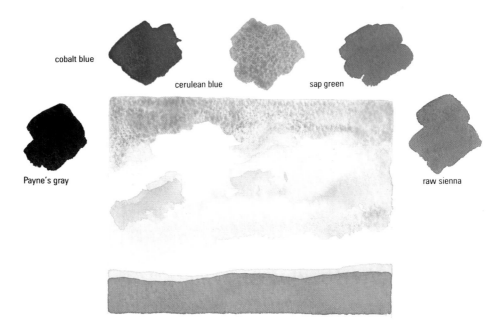

cobalt blue

cerulean blue

sap green

Payne's gray

raw sienna

● OIL/ACRYLIC

Although simplified for this exercise, the colored grays in these clouds make rich shadows. Yellow ocher and titanium white with touches of cobalt blue form one mix; cobalt, alizarin crimson, and white another. These are tempered with more white, Payne's gray and touches of sky color, blending and working the paint to create the desired effect.

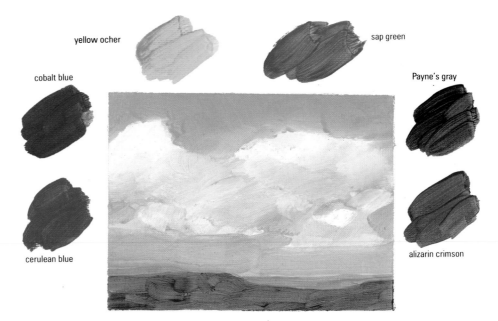

yellow ocher

sap green

cobalt blue

Payne's gray

cerulean blue

alizarin crimson

● PASTEL

Pastel colors are available in various shades, so you don't need to mix colors to achieve that special colored gray. Here the artist has chosen a selection of grays and blues and a very pale yellow ocher, which, combined and blended with white, create some credible clouds. Note how he has sought out the areas of dark and middle shades and highlight, and translated them into a flat, interlocking pattern.

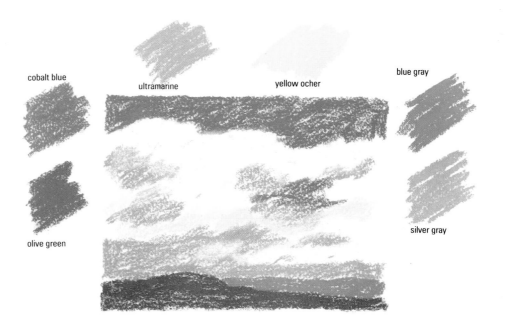

cobalt blue

ultramarine

yellow ocher

blue gray

olive green

silver gray

Fair-weather clouds

Gouache is a versatile paint that can be used diluted with water in the same way as watercolor, or thicker like oils. But it has a character very much its own; the paint has a smooth, matt, velvety texture that produces a richness of color quite unlike any other medium. David Carr uses the medium freely, producing atmospheric paintings which express his feelings for a landscape. He feels his way into the painting, starting with a brush drawing combined with washes of color. Once the composition is mapped out, he starts building up the paint, working from dark to light. Like any landscape artist, David Carr tackles common problems on the way: integrating the clouds into the sky; creating depth in the painting; and unifying the sky area with the landscape.

Colors
Ultramarine blue
Cerulean blue
Ultramarine violet
Indigo
Cobalt green
Viridian
Lemon yellow
Cadmium yellow (medium)
Yellow ocher
Cadmium red
Burnt umber
Titanium white

Brushes
White-bristle filbert, Nos. 6 and 8; Sable or sable mix, Nos. 3 and 12.

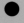

Support
This artist usually paints with gouache on cardboard, but gouache can be used on almost any ground that is free from grease or oil – paper, boards, masonite, or stretched linen.

Easel
This artist uses gouache of a near-dry consistency, and paints standing at an easel. However, many painters using gouache prefer to dilute the paint to a more liquid consistency and work on a flat surface.

1 With a white-bristle, No. 8 filbert brush, the artist intuitively explores the landscape. He finds this a particularly versatile brush, using it flat for laying washes and on its edge for drawing with the paint.

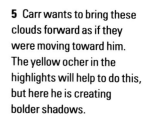

1

2 Carr considers this the end of the first stage. He has established the main areas of the picture, both the clouds and the landscape. Already conscious of unifying one with the other, he has the clouds echoing the rocks and the bay.

2

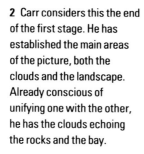

3

5 Carr wants to bring these clouds forward as if they were moving toward him. The yellow ocher in the highlights will help to do this, but here he is creating bolder shadows.

4

3 Now Carr starts to block in areas with slightly thicker paint. Colored highlights – white touched with violet and yellow ocher – are added freely. The strident violet mix will form the background of a rich build-up of delicate colors.

4 The bold brushwork is already giving life to this scene, but will be tempered later by overpainting.

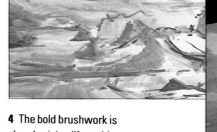

5

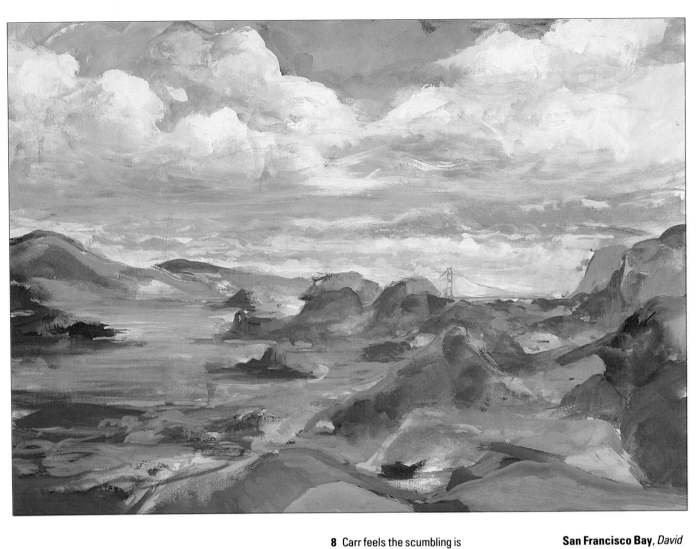

8 Carr feels the scumbling is too extreme. Loading a No. 12 softhair brush with a lot of clean water, he blends and softens the strokes.

7 Dry gray paint is scumbled into the clouds to give volume and definition.

6 The clouds are certainly beginning to come together. Working the sky into the clouds helps to integrate them and create a natural, atmospheric effect. Taking the sky color down to the water in the bay also helps to unify sky and landscape.

San Francisco Bay, *David Carr, gouache.*
Having checked that "the bay and the sky all unify in some sort of sense of light and space," David Carr decides the painting is complete. Knowing when to stop painting is not always easy. Try checking your work in a mirror for an "objective" view.

8

7

9 Now, returning to the bristle brush, the artist is bringing things together. Here he is touching up a highlight, but he also softens contours in the background so that they recede.

9

6

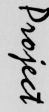

Paint a cloud study in which, instead of physically mixing your colors on the palette, you place the individual colors of the same shade side by side in small dabs and strokes on the paper, leaving the mixing to be done optically by the viewer. For example, a highlight may consist of patches of white with small dots of yellow ocher, while a shadow might contain patches of ultramarine, burnt umber, white, yellow ocher, and alizarin. Let the strokes touch and overlap each other, suggesting mixes – but not too much or the effect will be spoiled. When viewed from a slight distance, these separate strokes of color appear to fuse together into one hue, but because they are fragmented they reflect more light and therefore the color appears far more vibrant. This, of course, is the principle which the Impressionists used in their light-filled landscapes.

Payne's gray has its place and, like any other color, there are times when it is suitable to use it straight. Payne's gray, because it is such a delicate mixture of colors, can safely be used for darkening other colors.

Pastel colors come ready-mixed in a choice of tints, which can be very useful for making speedy cloud studies. For example, yellow ocher tint 0 is the very palest tint of yellow, perfect for a sunlit highlight. It will save you from some blending, but it is worth remembering that colors which are not too uniformly combined are often more interesting than those which are efficiently blended.

Cloud highlights

Highlights are not always found on the tops of clouds – it depends on the position of the sun. In the early evening, when the sun is low, the highlights are underneath the clouds and often tinged pink or yellow. You will notice that when the sun is high in the sky, the highlights on the tops of the clouds are yellow, reflecting the sun, and the shadows underneath have a bluish tinge, reflecting the sky. Yellow ocher rather than lemon yellow is better for mixing sunlit highlights.

Complementary colors in clouds

You will find that if you tint your grays with complementary colors, encouraging minute patches of the pure color, you will achieve more lively clouds. This means pitting highlights containing warm oranges and yellows against shadows containing cool blues and violets. These colors do not have to be used full strength; even merely tinting your grays with them will produce more vibrant clouds.

Rain and Floods,
Trevor Chamberlain,
oil on canvas.
Tackling a sky laden with rain clouds, Chamberlain started with a pinkish toned ground, which gives the painting unity and warms up the range of delicate grays used for the clouds.

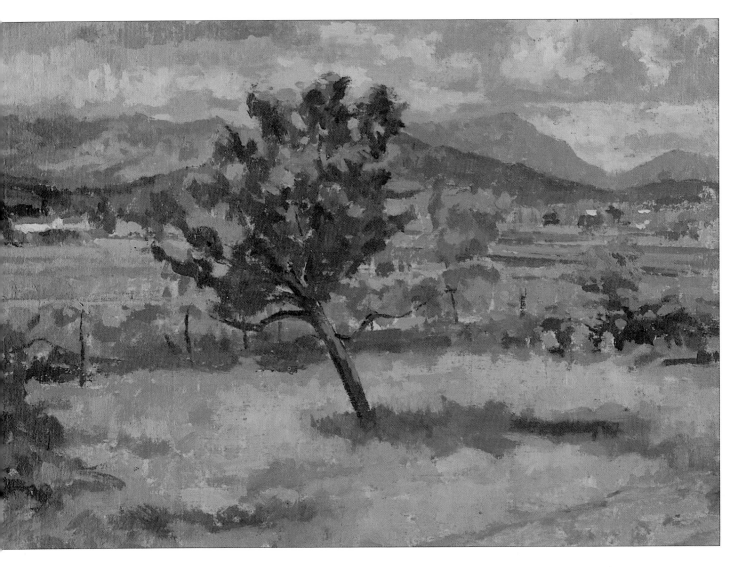

△ **View from Can-xenet, Majorca**, *James Horton, oil on canvas.*
There are so many different techniques for reproducing clouds. Here the pattern of light on the cloudscape is translated as a patchwork of delicate colored grays. With careful observation, the artist has built up the sky with dabs of paint, laid on cleanly to avoid blending; the colors mix in the viewer's eye.

◁ **St John's in the Valley**, *Stephen Crowther, oil on canvas.*
Those clouds which are closest to us often appear sharply defined. Here the artist has reproduced the delicate outline of the spring clouds with deft brushwork.

1 The artist has to work fast. As soon as the wash is completed, a crumpled piece of tissue is used to gently dab off the blue paint. Slightly more pressure is applied to define the clean edge of the brightly lit top surface of the cloud.

2 Having established the outline, the tissue is reshaped and used to lift off the main body of the cloud. As you work, vary the pressure applied with the tissue to create the irregular shape of the cloud. Take care not to rub the paper or you will destroy the surface; use a press-and-lift motion.

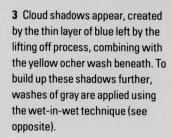

3 Cloud shadows appear, created by the thin layer of blue left by the lifting off process, combining with the yellow ocher wash beneath. To build up these shadows further, washes of gray are applied using the wet-in-wet technique (see opposite).

LIFTING OUT

The technique of lifting out produces, with little effort, magical amorphous clouds. In this watercolor demonstration, the sky is painted with a thin wash of yellow ocher, overlaid when dry with a thin wash of Antwerp blue. The clouds are created by lifting out the paint before it dries, using a crumpled tissue. (Alternatively you could use a cloth, a sponge, or even a dry brush, depending on the type of cloud you are creating.)

Techniques for painting clouds

We will now look at useful techniques for painting clouds in various media. Bear in mind, however, that painting is not about slick methods and handy formulas. Formulas are arrived at so that the artist can guard against the unpredictable or the unknown. Yet, as artists, we should seek out the unpredictable and the unknown.

It is always worth taking the trouble to sketch and paint from life, even if you do know one or two tricks and formulas, because the sky is so important in a landscape painting. A slick, mannered, all-too-perfect sky is devoid of any excitement or intensity, whereas a sky painted from direct observation will always reveal something of the artist's emotional response to the subject.

● Watercolor: this lends itself perfectly to reproducing the amorphous, translucent nature of clouds. Keep your colors as fresh and transparent as possible by not constantly reworking them – too much mixing makes them look muddy and lifeless. If you find an area is becoming overworked, it is better to start again. Similarly, make your brushstrokes as fluent and unlabored as possible, and don't be afraid to load your brush with plenty of color – remember that watercolor is much lighter dry than wet.

Many cloudy skies will start with the laying of a background color wash. It may seem a simple enough technique, but if you want to develop confidence in producing an even wash, you will need to practice. You will find more instruction on laying washes on page 60.

With watercolor it is possible to leave the highlights as unpainted white paper. As described above, the lit edge of a cumulus cloud often has a crisp, well-defined edge, while the shadows are soft and diffuse. You will need to plan your image beforehand to work out where the hard edges will fall, so that you can wash the background color around them. The soft, ragged parts of the cloud can then be allowed to fuse wet-in-wet with the background wash, making a soft edge. Knowing when to take this step – i.e., when the receiving wash has dried enough to prevent the second color from running out of control, but not so dry that ugly streaks and hard edges form – takes experience. But with watercolor, even the old and wise and highly experienced artist is still frequently caught out.

Another method of creating highlights is to dab the wet paint with a piece of crumpled tissue to reveal the paper beneath. This technique, known as "lifting out," can also be used to soften edges and lighten color. For example, use it to create soft, misty clouds or streaked wind clouds in a blue background wash. Experiment with the technique, using crumpled tissue, a natural sponge, or a cloth wrapped around your brush to produce different shapes and effects.

1 After lifting out the area of cloud (see opposite), the painting is allowed to dry. Then the surface is dampened down using a large brush. A pale gray is gently brushed on. A darker shade is added and allowed to dry.

2 A clean brush is used to lift out small patches of the gray to create a more natural cloud formations. When lifting out, a brush creates a softer edge than a tissue. If the paint spreads farther than you want, lift it off with a brush or tissue.

WORKING WET-IN-WET

The watercolor technique of wet-in-wet involves painting on wet paper or into a color that is not yet dry, so that the colors merge together. Practice this technique in order to judge how wet the receiving wash and the applied washes need to be to achieve the effect you want. If the washes run out of control, you can blot the paint with a tissue or lift out some of the moisture with a dry brush.

3 The result is light, fluffy, believable clouds. When dry, the colors appear less strong so you need to consider this when planning your painting. Further shadows could be added wet-in-wet if required.

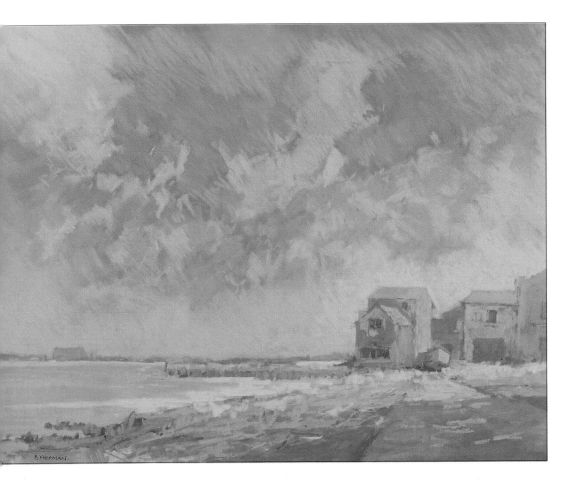

After the Storm, Walberswick,
Barry Freeman, pastel.
The freshness of this painting results from the use of complementary colors. The blues in the sky are complemented by the burnt sienna ground which shows through in small patches of pure orange and which tempers the thinner scumbles of white pastel. Cloud reflections in water usually appear lighter than the clouds themselves unless the sky is very light, in which case they appear slightly darker.

1 The artist has already prepared a cloudscape using the lifting out technique and painted the cloud shadows wet-in-wet (see pages 40–41). The area of white paper on the right will serve as a bright, sunlit highlight on the foreground cloud.

2 When the foreground clouds are dry, a brush is loaded with dark gray and another cloud is painted in behind them, leaving a sliver of white paper to serve as the highlight along the upper ridges of the foreground clouds.

3 It is remarkable how the addition of this area of strong contrast gives form to the cloudscape. Before the dark gray wash is dry, it is integrated into the sky area at the top by softening the edge with a clean brush dipped in water.

WET-ON-DRY

Painting wet-on-dry is the classic method of using watercolors, in which shades and colors are built up in successive layers; each layer is allowed to dry before the next one is added. The dry surface "holds" the paint, so the edge of a stroke does not run or distort. This technique is useful when painting the sunlit tops of clouds, which appear more hard-edged than the shadowed parts.

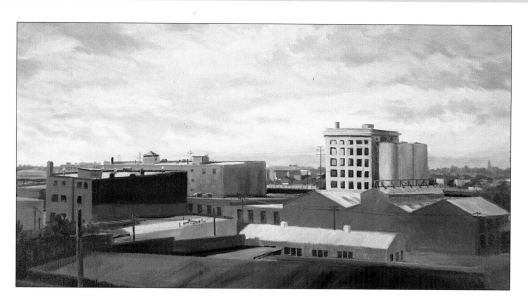

City Clouds, *Bruce Cody, oil.* Even on an overcast day, the sky is still the source of light. With the emphasis on cool blue grays, this light has little warmth in it.

Body color and pure watercolor work well together in cloudscapes. To give the sky a feeling of depth, try using delicate watercolor washes to portray the misty horizon and distant clouds, contrasted with touches of creamy, opaque body color suggesting patches of dense, advancing cloud. Use the body color sparingly, scumbling it on almost dry to give a broken effect that resembles vaporous cloud.

You can build up cloud forms with highly diluted, translucent, overlapping washes of colored grays, but avoid too great a buildup of paint; otherwise, your clouds will look more like rocks. Dark storm clouds can be given added interest with a granular effect, which sometimes occurs when a wet wash is applied over a dry one, or with certain colors, for example, cerulean and ultramarine blue mixed with burnt or raw umber.

● Oil and acrylic techniques for clouds: the techniques demonstrated here apply to oil and acrylic paints, both of which can be used thickly and opaquely or diluted to a thin wash-like consistency. Soft edges can be achieved by blending colors wet-into-wet directly on the canvas, or by gently stippling it on. When mak-

Luminous clouds

In this feature, we look at a painting in much closer detail, focusing on aspects of the work which solve common problems or are particularly interesting from a technical point of view. This wonderful pastel by Margaret Glass is alive with light and movement. You can almost smell the sea air and feel the fresh breeze on your cheek.

▽ At close range, the delicate coloring of these small clouds can be seen. Pale pinks and violets, left unblended, are set off by the dark olive tinted paper, which shows through in places.

△ In this denser part of the cloud, pale yellow, gray, pink, and blue are carefully blended into the white mass.

▷ In the shadows of this cloud, a wonderful confluence of colored grays are scumbled over each other to create an impressive richness of shade. The blue sky also is made from several blended layers.

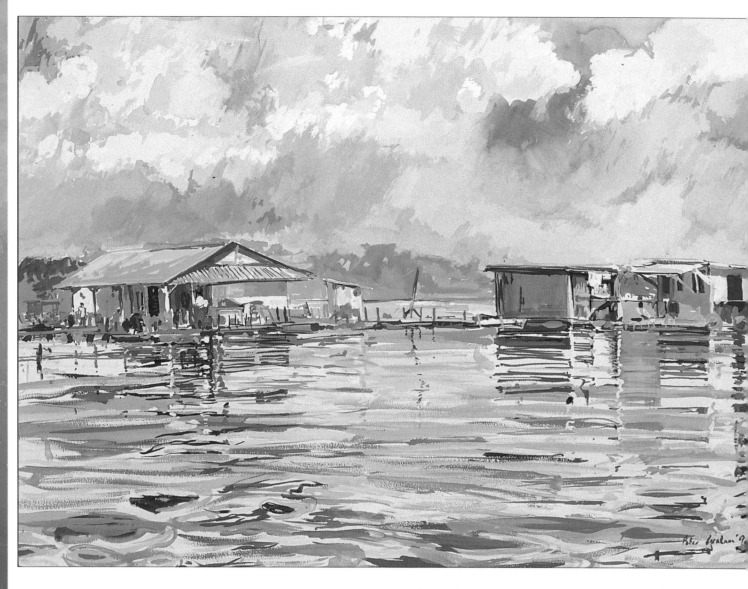

The Kelong, Singapore,
Peter Graham, gouache.
Exaggerating the colors in
these monsoon clouds and
their reflections below
produces an original
composition and confirms
the view as being tropical.

ing alterations, the paint can be scraped off with a
knife or wiped off with a rag when still wet.

Different types of cloud can be created with dif-
ferent techniques. Light, misty clouds can be stippled,
scumbled, or dry-brushed over the background color,
with transparent glazes added over the top. Heavier
clouds invite textural painting and impasto techniques,
creating lively brushmarks in the thick paint or laying it

on with a palette knife. Keep your brushstrokes relaxed
and fluid, letting the brush follow the gesture of the
clouds: if the wind seems to whip them upward, sweep
your brush up to catch the movement.

● Pastel techniques for clouds: many of the techniques
used in pastel are the same as for other media –
blending, stippling, scumbling – but the nature of the
medium dictates different methods. Blending is the
most obvious technique to use, given the nature of
both the subject and the medium, and can be executed
with the fingertip, a soft brush, or a torchon. Beware of
over-blending, however; introduce some energy into
your drawing with broad directional strokes.

The effect of working into wet or dry paint is
achieved in pastels by working into either fixed or un-
fixed pastels. If you fix a layer of pastel and then
scumble over the top of it, the new color appears
almost to hover above the layer beneath – perfect for
portraying thin, wispy clouds.

Turpentine can be introduced with a brush to oil
pastels on the paper to dilute and blend the colors.
Obviously this produces a less chalky effect, but it can
be useful for representing a shaft of light or a distant
squall of rain.

1 In this sunset sky, the artist is using a torchon – a rolled paper stick shaped like a pencil – to blend an area of fine yellow cloud into the surrounding dark gray sky. The torchon also helps to grind the particles of pigment into the paper.

2 The excess pastel pigment is removed with a soft mop brush, further blending the color in the process, but removing the chalky texture of the pastel. This technique is especially useful for indistinct background details or for fine gradations of shade.

3 The fingertip is often the most practical blending tool for the pastel artist – ready at hand, so to speak, and easy to clean. Here pale yellow is blended over a darker shade, allowing the latter to show through in places.

BLENDING PASTELS

In pastel, colors can be blended by rubbing with a finger, torchon, rag, or brush. Overblending, however, can make a pastel painting look slick and sugary; as with other media, partial blendings, in which the constituent colors retain their identity, are often more interesting than a flat, perfectly blended area of color. Oil pastels are less easy to blend than chalk pastels, but they can be diluted and mixed on the support with a brush dipped in turpentine.

1 The sunset cloudscape is fixed before small areas of highlight are scumbled over the top, using the flat side of the pastel to create a soft, broken stroke.

2 In the completed sunset sky, you can see the area of unfixed chalky scumble sitting on the surface of the work, giving depth and form to the clouds. Further scumbled areas can be seen in the dark browns above, worked over a previously fixed area of dark blue and purple.

SCUMBLING

In pastel, scumbling is an invaluable technique because it allows you to modify a color without clogging the surface of the paper. To scumble, simply use the tip or the side of the pastel stick to make loose, scribbled marks over an area of color. Work loosely and freely, allowing the undercolor to show through the scumble.

The question of whether or not to fix a pastel painting is a source of debate among many pastel artists. Fixing does prevent smudging, but it also partially destroys the chalky appearance of the work, and it tends to darken colors. A compromise is to lightly fix the work and then scumble over some areas with fresh pigment which is left unfixed.

△ **View of Sunset over the Mountains from Can-xenet, Majorca**, *James Horton, oil on canvas.*
Although underplayed, with only hints of the brilliant oranges and yellows present, this sunset projects the extraordinary luminosity of the sky at this time of the day.

▽ **Twilight**, *Roland Roycraft, watercolor.*
The brilliance of this "silver lining" with its carefully controlled hard edge, results from the contrast with the brooding darkness in the lower half of the painting.

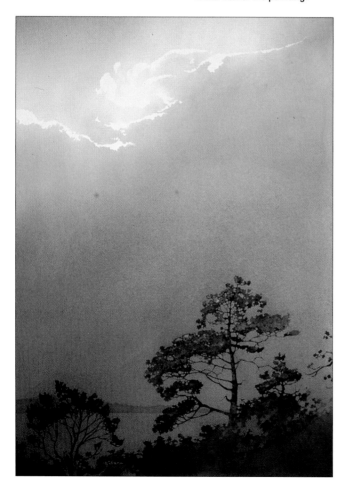

Sunsets and clouds

As any artist knows, sunsets are very difficult to paint without their appearing clichéd. The temptation is to go overboard with garish colors and high values, with the result that the clouds jump forward and appear to hang in front of the landscape below. A garish sunset will not produce the gasps of wonderment you expected, more likely wry smiles of sympathy.

Even though you may find yourself overcome by the extravagance of nature when faced with a sunset, force yourself to produce an understatement. It is no good producing a neon nightmare and saying, "but that's what it looked like" because the fact is that artists' pigments cannot reproduce the extraordinary *luminosity* of the sky. And it is luminosity, not brightness, that you want to achieve. The secret of painting clouds at sunset is to keep your colors as subtle and transparent as possible, and your brushwork simple. In addition, you can enhance the warmth in the sky by using cool, dark shades in the landscape.

Composing with clouds

When composing a picture, try to arrange the main compositional lines in the painting so that they lead the viewer around the scene like a guided tour. The idea is to hold the viewer's interest by leading the eye *into* the picture – not across it. The western viewer will "read" a painting from left to right, so ideally compositional lines should lead in from the left and on through the painting toward the center of interest. The eye will naturally follow along "lines" of light or dark tone – the edge of an outstretched arm, a fallen tree, a winding stream, or a horizontal band of stratus cloud.

If the clouds are the focus of your composition, place the horizon line low down and keep the landscape relatively simple so that it does not compete with the excitement of the sky. In a cloudscape, just as in a landscape, it is important to make a focus for the eye, such as the sun bursting through a cloud, or a dark

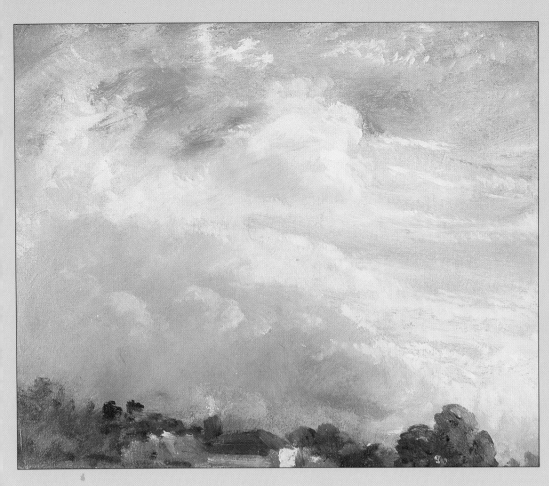

Cloud Study with an Horizon of Trees, *John Constable, 1821, oil on paper laid on board, 9½ × 11½in (24.8 × 29.2cm), Royal Academy of Arts, London.*
In June 1821 Constable took a house in Hampstead for the season and began a concentrated study of skies. Writing to a friend in October, he said "That landscape painter who does not make his skies a very material part of his composition – neglects to avail himself of one of his greatest aids." This oil study, painted on a red ground, depicts clouds scampering across an autumn sky. It is noted on the reverse "Noon 27 sepr very bright after rain wind West." The study is built up from a dilute underpainting of white over the red ground, forming the "gray" mass of the rain clouds, followed by white stippled highlights and wispy cirrus higher in the sky.

Low Tide, Morston,
Margaret Glass, pastel.
With the horizon line low, this sunset sky is undoubtedly the focus of the composition. Yellow highlights on the broken rafts of cloud lead the eye toward the center of light, as do the receding lines of the reflections on the mudflats below. Using the cloud formations in this way, the artist skillfully leads the eye through the composition and introduces points of interest on the way – the boats, the reflection of blue sky on the far mudflats, and the nicely worked area of sky above.

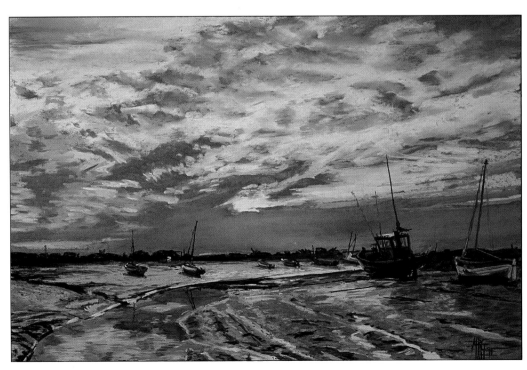

cloud against a patch of pale sky. The eye will naturally be drawn to such areas of contrast, but if possible encourage the eye to linger on the way to that focus with a discreet pattern of cloud forms. Compositional lines in clouds can also be used to guide the eye downward to focus attention on a center of interest in the landscape below.

One way of checking that your composition is satisfactory is to look at it in a mirror, or turn it upside down; any imbalance will be immediately obvious.

◁ **Blackthorn**, *Brian Bennett, oil.*
Here the rules of perspective have been applied to the painting of the sky, so that it recedes toward the horizon. In the foreground the clouds are painted in detail, with delicate-colored grays and strong contrasts between highlight and shadow. In the distance the clouds are less distinct, merging one into the other.

How to achieve depth in your skies

The rules of perspective apply just as much to the sky as they do to the landscape. To get a feeling of depth and space into your landscapes, you will need to create an impression of the sky receding toward the horizon, and this involves using both linear and atmospheric perspective.

Linear perspective is evident in the outlines of the clouds, which appear smaller, flatter, and closer together the further away they are. Atmospheric haze causes the colors of the clouds to appear cooler, grayer, and less distinct as they recede from our view – hence the term "atmospheric perspective."

Integrating sky and landscape

The sky is an integral part of the landscape, and yet we often see paintings in which the two seem to live different lives – the sky hangs heavily (and often vertically) in the foreground while the landscape appears to be behind it, causing viewers to lose their bearings. Most often this is caused by misjudging the relative tonal values of the landscape and sky. The sky, unless it is very stormy, is usually lighter in value than the landscape.

As mentioned above, a glorious sunset can sometimes lead you to mix colors too strongly, so that when completed the sky seems to burst forward out of the picture at you in a disturbing manner. The sky will also come forward if the clouds are too laboriously modeled with unnaturally stark contrasts and hard edges. The only way to tame such a sky and persuade it to take its proper place is to tone it down – either that or go for the second option of keying up the landscape below.

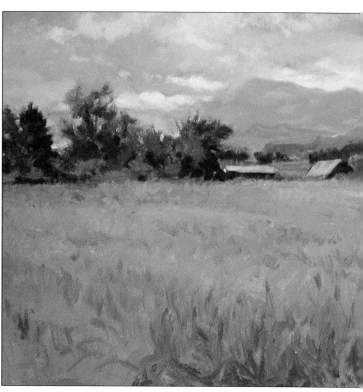

Incoming Storm,
Bruce Cody, oil on canvas.
In a well-integrated painting, the sky and the landscape are knitted together seamlessly. This is achieved by bringing down touches of the sky color into the landscape, for example in the distant hills, and by using the verticals of the trees to form a link between sky and land.

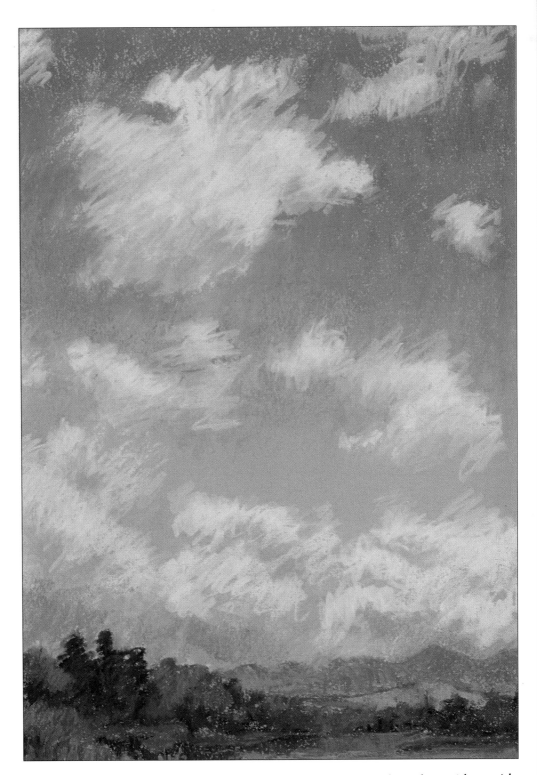

▷ **Dancing Clouds,**
Pat Pendleton, oil pastel.
Movement has been
expressed in these dancing
clouds through the lively
pastel line which describes
them. Toward the horizon
the line is less exaggerated,
and the clouds appear
smaller and closer together,
giving the effect of the sky
receding into the distance.

The French Impressionist Alfred Sisley (1839–1899) declared, "I always begin a picture with the sky" because in his opinion the sky affected almost every aspect of a painting. But other artists like to paint the landscape first, adding the sky in the correct mood when it is nearly finished. Whichever you start off with, it helps to integrate the sky and landscape if you work on them simultaneously and take across touches of color from one side to the other – small reflections of blue and gray from the sky to the landscape and touches of brown and green from the landscape to the sky.

Another way to link the sky and earth is through unified brushwork. For example, if you decide to paint the sky with broad directional strokes with a wide bristle brush, treat the landscape likewise. The rhythm of the brushstrokes will help to knit together the two physically diverse parts of the composition.

You can also link the landscape with the sky through elements of the composition. A tree in the middle ground, crossing the horizon and into the sky, will naturally join the two together. As the tree will overlap the clouds, it will also have the effect of pushing the sky back, thus creating a feeling of space and recession.

Visual harmony and balance are also achieved by the subtle use of repeated shapes; for example,

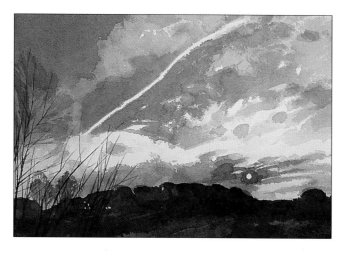

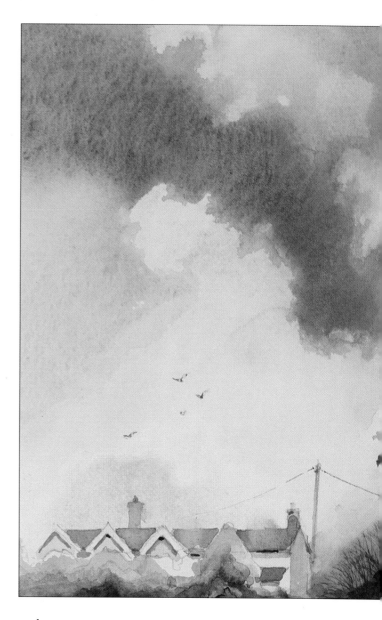

△ **Sunrise with Vapor Trail**, *Ronald Jesty, watercolor.*
A dramatic skyscape is created through the contrast between the ominous storm clouds on one side and the luminous blue sky and the light of the rising sun on the other. The strong diagonal of the vapor trail enforces this division and adds a note of exhilaration to the composition.

▷ **Clouds**, *John Lidzey, watercolor.*
This painting is an example of the power which the sky has in influencing the mood of a painting. Brooding over the dark wood, the bank of cloud appears to threaten the small cottage beneath. In complete contrast, the house on the left is haloed with soaring birds and white fluffy clouds, giving it a fairytale quality.

you might echo some of the shapes of trees or hills in the outline of a bank of cumulus cloud. Sometimes the sun shines through breaks in the clouds, casting patches of strong sunlight and cloud shadows on the landscape beneath. A swathe of light in the sky reflected somewhere on the landscape will link the two elements as the eye will naturally dart from one to the other.

Creating mood with clouds

More than any other factor, the sky in its various manifestations sets the mood of a landscape painting. Don't think of it merely as a backdrop, but use it to complement or enhance your landscape.

People usually think of cloudy skies as depressing, forgetting that there are so many types of clouds, most of which are exciting and optimistic in character. Spring clouds racing across a sparkling blue sky could hardly be described as depressing, nor could a towering bank of cumulus cloud moving majestically like a ship in full sail.

Clouds can also introduce a sense of movement

and energy into a composition. An army of wind clouds scurrying across the sky, painted with lively brushstrokes, will create an upbeat mood and set the pace for the rest of the composition.

Storm clouds, of course, can be either ominous and brooding, or dramatic and exciting, their strong purples and browns deepening the tone of the sky and creating an eerie light.

In complete contrast, a sky covered in a thick blanket of stratus cloud has a stillness and calm which can underline the mood of, say, a snow scene. The French Impressionist painter Camille Pissarro (1830–1903) visited London many times to paint scenes like this.

Last but not least, what could be more captivating than a stretch of water reflecting evening light, the clouds shot through with gold or suffused in a purplish haze? No wonder Constable wrote, "It will be difficult to name a class of landscape in which the sky is not the key note, the standard of scale, and the chief organ of sentiment."

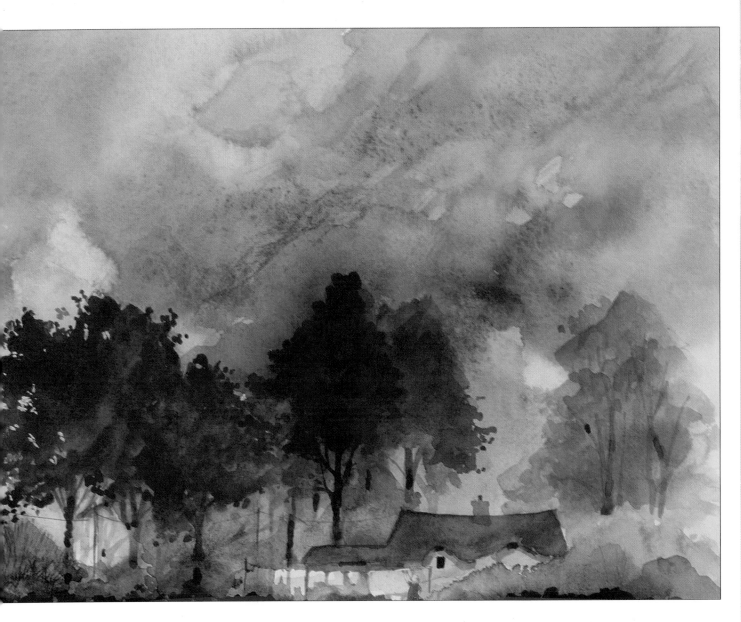

▷ **Cloud Shadows,**
Trevor Chamberlain,
watercolor.
The bank of clouds sets the
scene for a peaceful
composition. But it is the
effect of the strong sunlight
breaking through them to
form cloud shadows on the
sea and foreshore below
which has drawn the artist to
this subject.

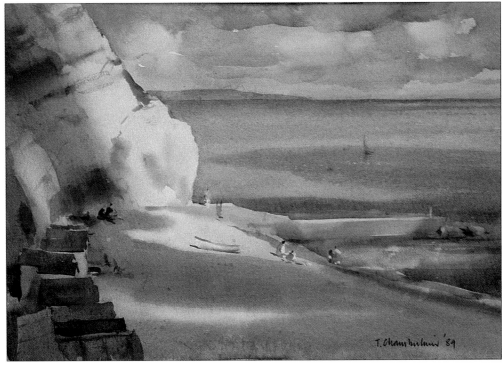

J. McCombs 91.

Sunlight and shadows

Summer Evening, Royal Oak Pub, Delph, *John McCombs, oil on canvas.*
Strong contrasts and long shadows suggest the evening light raking in from the left. The blue sky is worked over a warm red ground which shows through the lively brushwork. Hints of cloud are brushed over and scraped back with the end of the brush.

A clever artist it is who manages to fill his or her paintings with sunlight. The problem is that you are not painting something which is physically tangible, rather the effect that it has on your surroundings. Painting sunlight does not just involve painting blue skies: to capture your elusive subject, you have to create an atmosphere of warmth and luminosity, and this will make you draw on all your talents. It means learning to observe and judge tonal values; it means appreciating

The sparkling lights and deep shadows found on a clear bright day are a joy to behold and a pleasure to paint

△ **The Sentinels**, *Billie Nugent, oil pastel and watercolor.*
The shadows here form an important part of the composition, carving a way into the picture space. Although the scene is bathed in strong evening light, the overall temperature of the painting is cool.

▷ **Shobrooke, Devon**, *Lionel Aggett, pastel.*
The stark forms of late fall trees are offset by the golden evening light raking across the grass. The richness of color is achieved by allowing the red under-color to glint through scumbles of pigment.

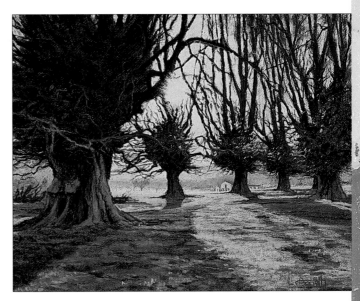

◁ **Ladies' Day Out**, *Roy Petley, oil on board.*
With the sun going down, the figures are seen *contre jour;* the golden evening light shines through flimsy clothing, surrounding the figures with a halo of shimmering light.

the importance of reflected light and vibrant shadows and treating them as a positive part of the composition; and finally, it means building up your painting with dancing colors and expressive brushstrokes that convey an impression of shimmering light.

So let us start at the beginning with blue skies. We will then look at how the quality of light at different times of the day or in different seasons can influence the landscape. We will learn how to cope with rapidly changing light, how to use the direction of the light to emphasize form or to create a mood, and how to paint luminous shadows. And all this will hopefully lead to paintings that radiate sunlight.

Mixing colors for blue skies

Blue skies are usually associated with those pulsating cornflower-blue skies of high summer, squinted at through half-closed eyes as you lie on the beach. But

(*Continued on page* 58.)

Sunlight and shadow studies

The artist will learn most by studying weather effects at first hand. But photographs are a useful way of recording information and for drawing attention to the lesser-known marvels of nature.

◁ Bathed in soft pink evening light, this cumulus cloud becomes a work of art on its own. Note how crisp the highlit top edge is compared to the shaded underside.

◁ The iced branches of these trees, backlit by the rising sun, create an abstract pattern of glittering light. In oils or acrylics, build up from the background, carefully mapping out the structure of the tree and then placing delicate touches of yellow and white light.

◁ The sun beats strongly down on this range of snow-covered mountains. But to make this snowscene believable, you will need to play up the cool colors, only adding touches of warm color to accentuate the cold by contrast.

◁ At sunset delicate streaks of cirrus are sculpted by the wind. Using watercolor, these patterns could be lifted off with a tissue wrapped around the end of your brush.

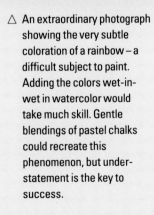

◁ Clouds lit by lurid pink sunset light often look false and garish when reproduced in paint. The answer is to play down the color, concentrating on delicate transitions of tint and shade, which are there if you look carefully.

△ An extraordinary photograph showing the very subtle coloration of a rainbow – a difficult subject to paint. Adding the colors wet-in-wet in watercolor would take much skill. Gentle blendings of pastel chalks could recreate this phenomenon, but under-statement is the key to success.

◁ **Red Wind Break**,
*Andrew Macara, oil
on canvas.*
The warm blue sky sets the
tone for the painting and is
taken through in various
shades – in the clothing and
the shadows – to unify it. The
brilliant red beach umbrella
forms an effective contrast.

▽ **Bay-window Books**,
Bruce Cody, oil.
Applied thinly in an uneven
layer, the sky here is a
cooler blue. The strength of
the color is reduced toward
the horizon, creating a
feeling of space and
recession and emphasizing
the bleaching effect of
strong sunlight.

there are blue skies of every shade and hue through-
out the year: the weak yellow-blue sky of a cold winter's
day, the deep luminescent blue sky which comes after
a snowfall, and the cool blue of a spring morning.

All of these skies require different color mixes
and it is well worth trying various combinations of color
yourself to discover the variety of blues – warm and
cool, subtle and intense – it is possible to create. You
might find it useful to make a series of charts which you
can keep for reference and inspiration.

Buying blues

First of all, let us look at some of the ready-mixed
blues that you can buy in a tube, pan, or stick. Artists
rarely apply these blues as an unmodified, flat expanse
of color, but will dilute them, lighten them with white
or lemon yellow, make them pinker with alizarin, or
darken them with Payne's gray. Each of the blues listed
below has its own characteristics.

● French ultramarine is the rich purply blue of a
summer's day. This blue is strong so it is usually diluted
or tinted.

● Cerulean means "sky blue," so you might guess that
this is a useful color for skies and other atmospheric
tones. Cerulean is not a very strong blue and is useful
when painting cooler, less intense blue skies as it is
easily subdued by the addition of another color. In
watercolor, however, cerulean does not mix well with
other colors and is best used pure.

● Prussian blue is a very strong, cold, greenish blue. In
its original form it was unstable so, to a great extent, it
has been replaced by the chemical phthalo blue – the
equivalent of Winsor blue (Winsor & Newton) and

Filtered light

In this feature, we look at a painting in much closer detail, focusing on aspects of the work which solve common problems or are particularly interesting from a technical point of view. In this picture Simie Maryles has successfully captured that most elusive of qualities – sunlight. This pastel radiates light and summer warmth, in part because the red ground is visible throughout the picture.

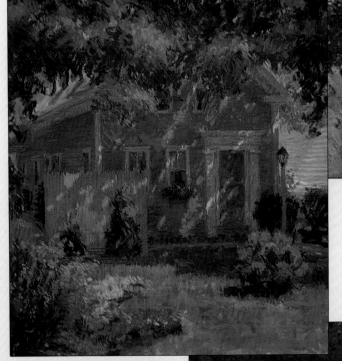

▽ The treatment of sunlight and shadow on the house is masterly, with combinations of crimson, brown, and touches of violet in the shadow, and orange and scarlet in the light. Note, too, the coloured shadows on the "white" window frames.

△ The sensation of light filtering through the trees is created by building up from dark to light with small strokes of color.

◁ This wattle screen is created with feathered strokes of pale violet over ocher and red. The patches of sunlight in a lighter tint of ocher are woven in with overlapping strokes of violet.

△ The play of sunlight and shadow on the grass appears vibrant because of the complementary greens pitted against the red-toned ground.

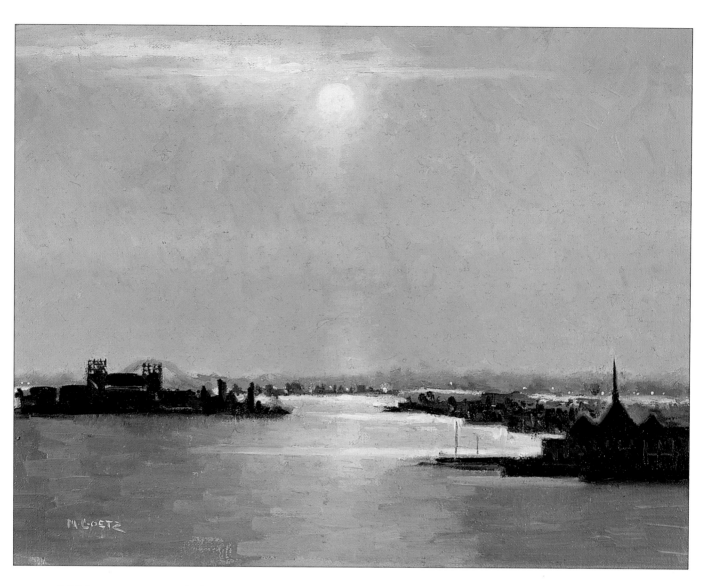

M. GOETZ

monestial blue (Rowney). A little of this blue goes a long way.
● Cobalt blue is less violet and less intense than ultramarine, but is a clear, rich color, very useful for skies.

Atmospheric perspective

The effects of atmospheric perspective apply to clear skies just as they do to cloudy skies. If you imagine the sky like an upturned soup bowl above your head, the rim of the bowl is farthest away on the horizon, where the color of the sky is cooler and less saturated than it is directly overhead, due to atmospheric haze.

A common way of dealing with this progression of color in opaque media is to mix three shades of blue: the darkest and warmest for the top band, a medium shade for the center band, and a pale, cool tone for the bottom band. For example, you might mix ultramarine – a warm blue – with just a hint of red for the top band, followed by cobalt blue mixed with white and a touch of yellow, then progress to cool cerulean blue mixed with more white and yellow. Work the adjoining bands lightly into each other wet-into-wet so that they merge imperceptibly, but keep your brushwork lively.

These colors are merely suggestions, and it is far better to work from direct observation and mix your colors accordingly.

In watercolor the effect of recession in a clear sky can be expressed by means of a graduated wash. Working on stretched paper, and using a natural sponge or a large round brush, dampen the sky area with clean water. Tilt the board slightly to help the paint flow gradually down the paper. Start at the top of the paper with a fairly saturated warm blue and steadily progress down to the horizon line, gradually lightening the tone by adding more water to the pigment. Again, depending on the actual colors in the sky you are painting, you may wish to introduce hints of other colors into your blue wash.

When the wash is completed, let it dry in the same tilted position; otherwise, the paint will flow back, and create ugly ridges as it dries.

Two tips for painting watercolor skies: make sure the color you mix is strong enough, because it will dry much lighter, and mix twice as much paint as you think you will need. It is surprising how much the paper soaks up, and there is nothing more frustrating than running out of paint in the middle of a wash.

You may find it easier to apply a graduated wash

◁ **Sunset, Ellis Island**, *Mary Anna Goetz, oil on canvas.*
The effect of atmospheric perspective is achieved in this luminous sky by progressively diluting the hazy blue paint toward the horizon, allowing the warm golden ground increasingly to show through.

▷ **The Terrace at Can-xenet, Majorca**, *James Horton, oil on canvas.*
Here the spatial depth in the landscape is echoed in the sky, with the ranks of summer cloud becoming smaller, closer together, and less distinct in the distance.

1 An ocher wash is laid, allowed to dry, then wetted. Next the artist applies Antwerp blue, alizarin crimson, light red, and cadmium yellow using bold looped strokes.

2 The painting is tilted first one way, then the other to encourage the paint to run and merge. It is left to dry in the same tilted position to prevent the paint from flowing back and creating ugly ridges as it dries.

3 The result is a delicate variegated wash.

LAYING GRADUATED AND VARIEGATED WASHES
A graduated wash uses one color only; a variegated wash uses more than one color. Either wash can be used to good effect to suggest recession in a sky. Variegated washes tend to be less predictable than single-color washes, but results can be stunning. Whichever type of wash you are using, the key to success is to keep the watercolor paint as fluid as possible – and don't hesitate when applying it. Be bold.

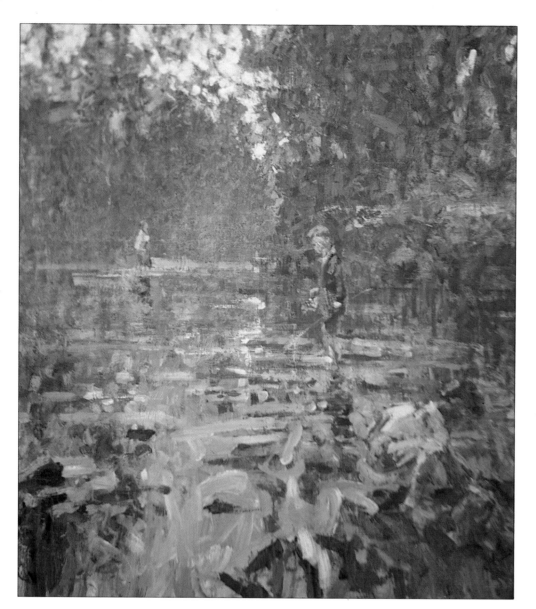

◁ **Towards Fresh Woods,**
*Arthur Maderson, mixed
media.*
Between sunset and dusk at
the end of a hot August day,
the sky appears white,
bleached of all color by the
power of the light. The
shadowy creek is painted
with shimmering blues,
complementary to the warm
yellow sunlight glimpsed
behind the trees.

▽ **North Hill, Malvern,**
*Paul Powis, oil on
canvas.*
A blue sky is always tonally
lighter than the landscape
below. Sometimes it is
difficult to judge relative
shades while the work is in
progress, and it helps to
paint the landscape first,
adding the sky at the end, as
the artist did here.

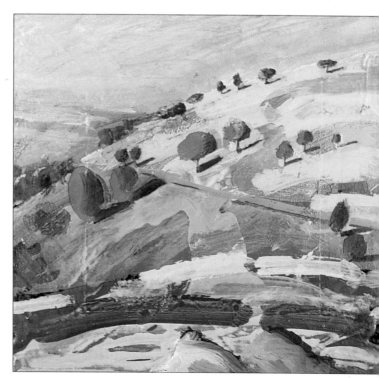

"upside down," adding the color rather than subtracting it. Pencil in the contours of the horizon and then turn your paper upside down. Start your wash at the horizon with the color diluted and add more color as you work down the paper.

Painting a vibrant blue sky

Inexperienced artists often find it difficult to capture the intensity of blue, and the light which emanates from it, of a high summer sky. On a clear day, the sky positively pulsates with light, but it is impossible to translate this into paint because pigment is opaque and absorbs light. The artist must therefore resort to artifice and create an *impression* of shimmering light by mixing colors optically – in the eye rather than on the paper or canvas. Optical mixes, as we all know, were used to great effect by the Impressionists in capturing the elusive nature of light. The principle is based on the fact that our eyes are unable to focus properly on small areas of color which are the same shade. The colors resonate on the retina, in effect "dazzling" us, just as light dazzles. For example, green can be mixed

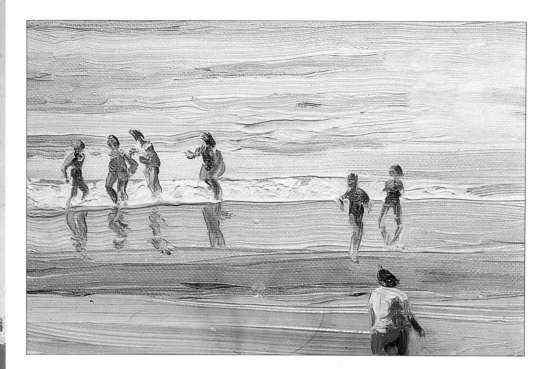

◁ **Bathers in the Sea**,
John Plumb, oil on canvas.
Painting weather is not just about painting skies, as this small work 4 × 6in. (10 × 15cm) demonstrates. Using a limited palette of cool grays, blues, browns, violets, the artist successfully evokes the atmosphere of the seashore on a chilly day.

▽ **Les Tuileries**, *Ray Evans, pen and watercolor.*
In this sketch the figures are framed by the strong verticals of the trees, which are themselves countered by the horizontals of the long evening shadows.

blue. Alternatively, another approach would be to leave the sky alone altogether and key up the values in the rest of the painting.

Quality of light

In order to capture an impression of light in your paintings, you have to be able to judge its quality. This quality can be seen in the color and strength of the light and the effect it has on our perception of what is before us. There are various factors which affect the quality of the light: the weather, the time of day, the time of year, and of course where exactly you are in the world and how close to the equator.

Time of day

It can be very instructive to record in a series of sketches or paintings the effect that changing light throughout the day has on a particular scene. There are various things you will notice when you compare them.

● Shade: The light is weaker in the early morning and evening when the sun is low in the sky, so the tonal values are softer and less intense. Such light reduces the limits of the tonal range, but it plays up the variety of the middle shades. In contrast, the power of the midday sun pushes the tonal range to its extremes, but you will find it bleaches out the subtle middle tones.

● Color: Sunlight can cast a cold, blue light in the early morning and a golden or pink light in the evening which will qualify all colors it falls on. At these times of day, colors are generally softer, graduating from highlight to shadow more gently. In bright sunlight, colors appear more vibrant with few middle shades between highlight and shadow.

● Outline: You will notice that the weaker the light, the softer the outline an object has. In the light of dusk, even objects in direct light will have soft outlines, while those in deep shadow will be almost indistinct. Bright sunlight produces clearly defined edges where it shines directly on objects.

● Shadows: As the sun travels across the sky, shadows alter in length, position, color, and value. Strong light produces dark, hard-edged shadows, while soft light produces paler, ill-defined shadows.

Time of year

It is easy to become obsessive about recording the effects of changing light on a particular scene. Claude Monet (1840–1926) certainly was; between 1890 and 1894 he concentrated on the observation of a single subject in a succession of different lights, which resulted in his famous "series" paintings devoted to haystacks, poplar trees, and to Rouen Cathedral. Although it is easy enough to study these paintings in photographs in books, sadly, you will not get full value from them unless you see them "in the flesh." Miraculously, Monets are collected together from museums all over the world every now and then but the opportunity to see them is not practicable for everyone.

(*Continued on page* 70.)

● WATERCOLOR

A warm, luminous sky is created with a wash of cobalt blue with a hint of cadmium red, adding a little yellow toward the horizon. Note how the texture of the paper helps to break up the wash, giving it a granulated texture. The tree shadows are made with superimposed flat washes of sap green mixed with touches of yellow, blue, and red to vary the color and shade.

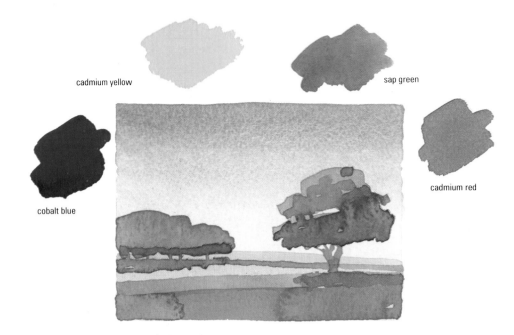

cadmium yellow

sap green

cadmium red

cobalt blue

● OIL/ACRYLIC

The artist has created a hazy summer sky by working the paint over the canvas texture with diagonal sweeps of the brush. These brushmarks may be understated since the paint is thin, but they help to create a lively surface. Also adding to the interest of the sky area are the subtle variations in the density of the blue.

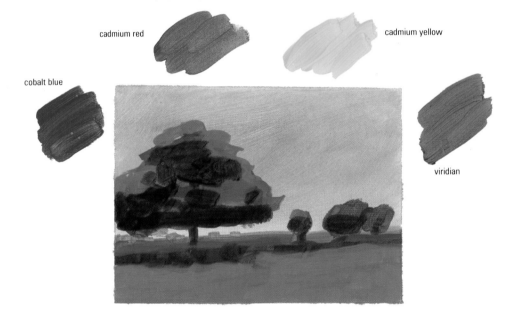

cadmium red

cadmium yellow

cobalt blue

viridian

● PASTEL

For the sky here, three bands of color have been merged; at the top cobalt blue, then a lighter tint of cobalt and toward the horizon a pale ocher. These are blended into one another, finally adding white to the yellow above the horizon. The artist has taken care not to apply the color too densely, so that pinpoints of white show through from the textured paper, giving an effect of scattered light.

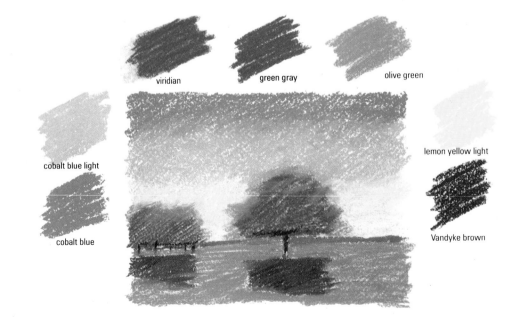

viridian

green gray

olive green

cobalt blue light

lemon yellow light

cobalt blue

Vandyke brown

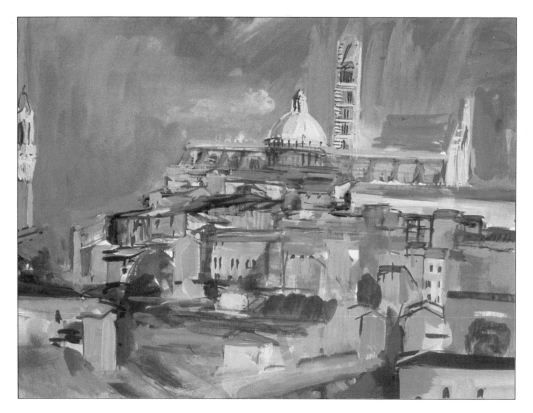

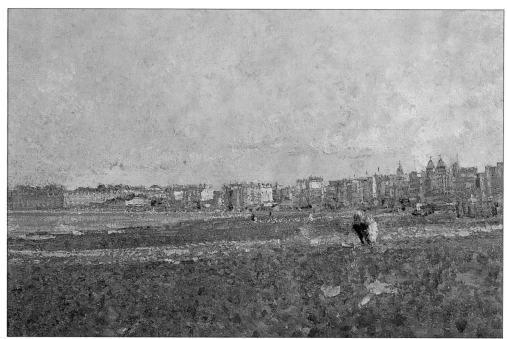

◁ **Siena**, *David Carr, gouache.* This area of blue sky is enlivened by colored grays scrubbed on with bold, multi-directional strokes. This technique could be used to knock back a blue sky which appears too strong.

▷ **Evening Shadows, Weymouth,**

Arthur Maderson,

oil on canvas.

The delicate hues of this hazy evening sky were created with transparent glazes of salmon, blue, and violet, overlaid with scumbled strokes of lighter colors. The technique captures the shimmering, vaporous quality of a coastal sky.

You may find it easier, particularly if the composition contains only a small area of blue sky, to paint the rest of the picture first and then add the sky in a lighter shade.

If, however, the sky dominates the composition, leaving an expanse of sky until last can impair your judgment of the values in the landscape below. In cases such as these, it is a good idea to block in the sky area with a pale blue wash and then work it up when the rest of the painting is well on its way. Working back and forth between the sky and the land is also a useful exercise; it helps to integrate the two, thus creating a more natural and atmospheric effect.

To help you judge the comparative tonal values in a complex landscape stretching out before you, look at it through almost closed eyes. This helps to take the colors out, leaving you better able to judge the tones. This method will also help you to assess the tonal values of your pigments when you are mixing them on the palette.

If you find that you have misjudged the intensity of the sky, making it too dark so that it appears to leap forward from your finished painting, you have a choice: you can knock back the sky tone with a wash or glaze of white, with a minute amount of the complementary color added to reduce the intensity of the

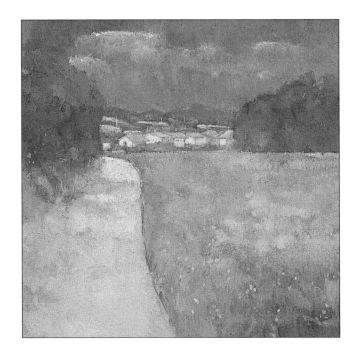

Approaching St Montan, Ardèche, *John Dehany, oil on canvas.*
This vibrant blue sky has been worked in many subtle shades of color. The paint is applied with a dry brush, with a lively directional brushstroke.

from yellow and blue; but a green composed of small dabs, flecks, or strokes of yellow and blue, left un-blended, appears more vibrant because the pure yellow and blue are still discernible, and they resonate on the eye. (It is important to point out, however, that this only works if the constituent colors are of equal or near-equal tone.) Optical mixes also appear more vibrant because the paint is applied in small dabs, strokes, and stipples, which themselves have more energy than a flat area of smoothly blended color.

So, getting back to our blue sky, the trick is to introduce hints of warm pinks, mauves, and yellows into the blues, leaving them only partly blended at most, and to let the marks of the brush show rather than blending them out. This works particularly well with oils, acrylics, and pastels; with transparent water-color you have the advantage that light reflects off the white paper beneath, lending its own luminosity.

Judging the tonal strength of blue sky

When you are faced with the intense blue of the sky on a perfect summer's day, the temptation is to paint it with the deepest blue pigment you can conjure up. However, this could lead you into trouble because the shade of the sky can easily become too strong – and the rule is that a blue sky is always tonally lighter than the landscape below.

1 This flat area of pigment is produced with the side of the pastel. With hard pastel, you may need to work it into the surface of the paper with your finger.

2 Starting at the top with a deep violet, and then graduating to a lighter shade, light feathered strokes are applied over the blue area.

3 Working through pink, pale blue, and white, the colors are optically blended. The final effect is of a shimmering blue sky which radiates light.

FEATHERING
Feathering is a pastel technique with a number of uses. Here it is used to enliven a flat blue sky, giving it a shimmering texture. But feathering is also useful for altering the temperature or the shade of a particular area of color, for softening hard edges, and for unifying the surface of the painting.

63

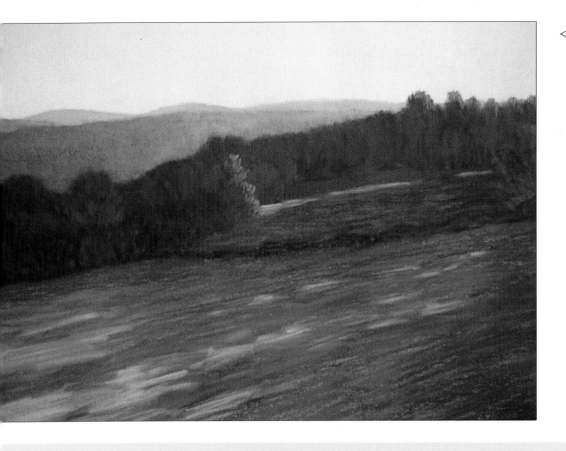

◁ **Evening Shadows**,
A. Woods, soft pastel.
Evening light in early fall
produces soft, indistinct
shadows, here achieved by
superimposing diagonal
feathered strokes of dark
green over the yellow-
greens of the patches of
sunlight.

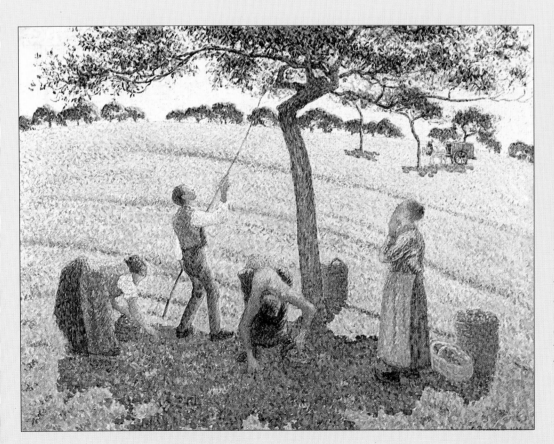

**Apple Picking at Eragny-sur-
Epte**, *Camille Pissarro, 1888
23½ × 28½ in (60 × 73cm), oil
on canvas, Museum of Fine Art,
Dallas.*
Here Pissarro is following the
scientific theories on color
mixing evolved by the pointillist
painter Georges Seurat. The
entire picture consists of small
brushstrokes of pure color
which are fused in the viewer's
eye, creating a shimmering
illusion of light. The shadow of
the tree, for example, contains
cool greens and blues, with
touches of warm oranges, reds,
and yellows suggesting reflected
sunlight. Through this mass of
color, spots of bright white show
from the canvas priming, adding
to the overall impression of
pulsating heat.

Dramatic shadows

This scene was painted on the banks of the River Orb in southwestern France. The work was completed over three afternoons, between noon and 4 p.m., so that the light remained consistent throughout. The idea for the composition came from the seated figure in the foreground framed by the dark trees, with the patch of light on the river, viewed through the trees, in the background. As the artist worked, figures entered and left the scene, and were included in the picture and removed until the perfect combination was arrived at. This artist works intuitively, building up areas of dark color and then adding highlights. The high contrasts, which were finally balanced only in the last moments, make this a very dramatic work.

Color
The artist used a selection of colors.

Materials
A selection of hard pastels used on the smooth side of Le France Bourgeois pastel paper in an olive gray middle shade.

Easel
The artist uses a backpack easel which folds to a compact size and has shoulder straps, leaving the hands free.

1 The overall tone of the scene is set with touches of pure color loosely hatched on. The artist is feeling for patches of light, exploring what is in front of him. The female figure is central to the composition and is therefore more fully detailed at this early stage.

2 The outline of the composition and the areas of color are still being explored. Here another figure is added. The color is built up and then blended and removed with a sponge.

3 Now the figure can be redefined over the under-color. The shadow is built up with blues, greens, and ochers, the color lightly blended with the fingers.

4 Next the reflected light from the blue sky outside the picture is taken through the pastel in blues and violets, now in more definite hatchings.

Banks of the River Orb,
John Martin, pastel.
This dramatic composition is set like a theater, with the audience in the foreground and the play in the distance, spotlit by the sun and framed by the trees. The addition of patches of sunlight throughout the scene has brought it to life.

8 The picture is almost complete. The artist puts in some finishing touches with a medium-blue pastel.

8

5 To increase the tonal contrast, this area of foliage is developed with super-imposed patches of color. It is time to check the tonal composition of the picture as a whole, by scrutinizing it through half-closed eyes.

7 To capture the hazy light shining through the trees, pale pink is scumbled lightly over the darks in a misty film.

7

6 More highlights are added, using ochers and pinks to match the build up of darks in the shadow.

6

5

69

The Neighbor's Place,
Laura Duis, watercolor.
The rough tooth of the paper
(Strathmore 2-ply Bristol)
means that tiny dots of white
show through the color,
making the surface dance
with light.

**MAKE A SERIES RECORDING
LIGHT**
Using any medium you like,
make a series of paintings of
the same view in different
seasons and under different
kinds of light. Following in
Monet's footsteps, try to
record the differences in
shade, color and mood
which occur under various
weather conditions: cool
spring sunshine, the heat of
summer, the mists of fall,
frost and snow in winter.
Obviously this is a long-term
project, so make sure you
choose a view that you can
get to easily, somewhere
close by that interests you.
You may even consider
choosing somewhere that
you can see from the shelter
of a car, to which you can
retreat if you are defeated by
wind, rain, or cold.

As far as when to paint
is concerned, you can try
being efficient and make a
date with yourself – like the
first Saturday in every
month. But the effects of
weather and light you are
seeking may not necessarily
occur on these days. In a
way, it is better to paint
when you feel like it, when
the light inspires you. Don't
force your series, simply let
it evolve over time.

Whether or not you get an opportunity to study
such a series at first hand, there is no reason why you
cannot create one of your own. I need hardly say that
you will gain enormously from doing so, but I realize
that such a project is very demanding on all but the
most organized and strong-willed of us. As Monet him-
self often found, it can be extremely frustrating when
you fail to catch a magical but all too fleeting effect –
and then the light changes and you lose it.

△ **Corona del Mar**,
Susan Clover, pastel.
The drama of the setting sun is seen in its reflection across the surface of the sea, captured in carefully placed patches of pure color.

Woman of Galladoro Sicily,
Ray Evans,
pen and watercolor.
Use sketches to explore the tonal values of a particular time of the day. Here, the sky is still blue, but the sun is weak.

At the end of a year you will be able to analyze your series. Below are some general points to watch out for – but bear in mind that an artist often has to manipulate the truth in order to convince the viewer. You can paint a sunlit winter landscape with pinks and yellows in the highlights, but if you want to get across the ferocity of the below-zero temperature, you will have to play up the cool colors and play down the warm ones.

● Color: Sunlight in winter is generally weak, with a cool blue cast. Daylight in the heat of summer is stronger and warmer. Look carefully and you will see there are more yellows and pinks.

● Tone: Because the sun is not as strong in winter, the tonal variety is narrower than in summer. Sunny fall landscapes seem particularly vibrant because of nature's happy conjunction of complementary colors – the blues and purples of the sky juxtaposed with the oranges and yellows of the leaves.

● Shadows: The sun does not rise so high in the sky in most places in winter, so shadows cast on the ground are longer throughout the day. They are even longer and softer in the morning and evening. In midsummer the sun casts dark shadows at noon. The sun then can still be quite strong in the evening, casting well-defined, long shadows.

◁ **Casas del Calvario**,
Olwen Tarrant, oil on canvas.
The sun here is beating
down almost from overhead,
but the scene chosen
contains few cast shadows
to complicate the task of the
artist.

▷ **80° in the Shade**,
Margaret Glass, pastel.
Strong overhead light
dapples the floor, lighting up
this corner of the yard.

▽ **Maryland House**,
Bryn Craig, oil.
In changing light, it helps to
establish the shadows at the
outset so that they remain
consistent during the
painting session.

Directional light

When you are painting a landscape outdoors, bear in mind that the direction of the light will affect not only the composition but every aspect of your painting.

For most artists, three-quarter light is the preferred choice. When light strikes the subject from an angle of about 45 degrees – from fairly high up and slightly to one side – the horizontal and vertical planes of the object are accentuated. This creates a strong, lively image because form, volume, and texture are well defined, and there is plenty of tonal contrast.

However, there are other kinds of light which are worth considering and which produce unusual effects. Try painting with the sun behind you so that your subject is lit from the front. Notice how the shadows stretch out away from you, often with some unexplained (to the viewer) compositionally interesting shapes in the foreground, leading the eye into the picture. Front light should be chosen if you want to accentuate color, or if you wish to emphasize the two-dimensional pattern of your subject; descriptive modeling is minimal because there are virtually no visible shadows (apart from those in the foreground).

A backlit scene, with the sun behind the subject, again is an interesting proposition producing an unusual distribution of shades. This normally occurs at dawn or dusk, when the sun is low in the sky and perhaps partially obscured by cloud. The forms of the land are thrown into deep shadow, sometimes almost in silhouette, against a bright sky. There will be "haloes" of light around less dense objects, such as when light catches the thin outer branches of a tree. Shadows will come toward you, creating influential compositional lines.

Coping with changing light

Unfortunately, you cannot freeze the sun's relentless progress across the sky, so you have to learn to cope with it. "Work fast," they say – but that is always more easily said than done. You may find it helps to restrict yourself to working on a small scale, using a large brush and few colors. This will certainly encourage speed and discourage time wasted on detail, but you may not want to produce this type of work. If you don't want to be hurried, you could try tackling the shadows first, so at least their positions are fixed, and building up the

◁ **Pollensa, Majorca,**
James Horton, oil on canvas.
The shadows cast by these
cypress trees animate the
geometric forms of the
sunbaked steps. A coarse-
textured canvas helps to
break up the paint so that the
warm ground shows through.

painting around them. Still another solution is to paint
for only an hour or so at a time, returning to the same
spot, at the same time of day, until the painting is
completed – if you can rely on the weather to remain
constant, that is.

If you have to finish your painting in one sitting,
amass at the start as much information as you can. Your
visual memory can be improved if you work at it by
concentrating hard and exploring every part of the
scene as if you were painting it. Study the comparative
values, scan the contours, explore the character of the
patches of light and shadows. Some artists find that
sketching these aspects in any detail tends to impair
the power of the memory. But it helps to do both.

Unless you specifically want to paint a scene in
bright sunlight, you will be better advised to paint
outdoors on a slightly overcast day, when drastic
changes in the position and intensity of lights and
shadows are less likely to occur.

Painting shadows

Without shadows, light does not exist. So if you want to
paint pictures filled with sunlight, you will need to
master the art of painting shadows. You can paint a
bright highlight, but without an equally dark shadow to
give it emphasis, that highlight will not mean anything.
As we have seen above, shadows vary enormously,
depending on the quality of the light. In bright sunlight,
shadows are hard-edged and dark; in more gentle light,
they are subtle and indistinct. But more than that,
changes in the quality of the light during the day and

◁ **Beech Forest Pond**,
Joyce Zavorskas, monotype.
Shadows and reflections
merge in this peaceful pond
to make a pattern of subtle
blues and greens.

Sunlight, *Frank Benson,*
1909, oil on canvas, 32½ × 20in.
(71 x 44cm), Indianapolis
Museum of Art.
Frank Benson has succeeded in
capturing the effect of bright
summer sunlight here in the
billowing white dress of the
young girl. The highlights are
applied with thick paint and a dry
brush over a thin layer of
shadow color – ochers and
colored grays. Notice the blue
reflected from the sky across the
girl's shoulders and upper arm.
The vibrant sky comes across as
the constant blue of a bright
summer's day, but it is in fact
made up of lively, broken
brushstrokes in a variety of
shades. The blue, which
becomes paler toward the
horizon, is brushed on with a dry
brush, working lighter tints into
darker ones, over a pale ocher
ground which shows through
increasingly toward the horizon.

▽ **Jenny Lake Lodge VII**,
Bryn Craig, oil.
Bright sunlight casts these
dark, hard-edged shadows.
Note how the shadow is
more intense near the object
casting it; reflected light
from the sky lightens the
outer edge of the shadow.

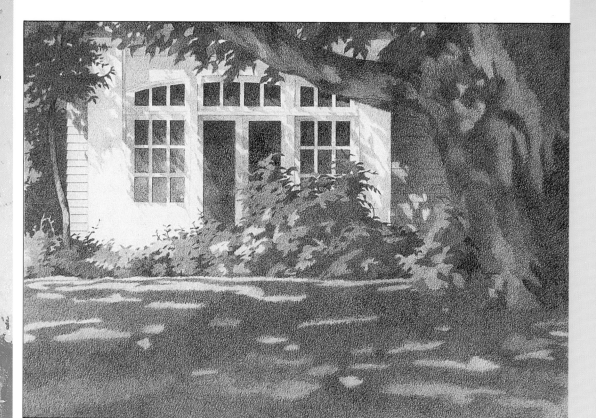

△ **Green Persuasion**,
Laura Duis, watercolor.
These soft-edged shadows, dappled with sunlight, capture the mood of a lazy summer's day. The pattern of shadows animates the stretch of grass in the foreground, leading the eye into the picture.

according to the season affect the shade, color, and configuration of the shadows cast.

It is a common mistake to regard shadows as negative areas of a painting. Not only do shadows help to strengthen the compositional structure, they can also contribute to the atmosphere of a scene and to the mood you wish to convey. For example, bright, crisp sunlight casts sharply defined areas of light and shadow that will emphasize the bracing atmosphere of a seaside scene. But that same scene, painted in late afternoon when the shadows lengthen and the light is hazy, will have an air of calm and peace.

The American realist painter Edward Hopper (1882–1967) springs to mind as an artist who really knew how to use shadows. He spent most of his summers on Cape Cod, where the summer light is especially intense, and painted the simple buildings and barns casting emphatic shadows which lent a haunting quality, an uncanny silence, to the setting.

Seeing color in shadows

Dull, lifeless shadows are the result of lack of observation. Shadows are never completely black, and only rarely are they a neutral gray. The color of a shadow is influenced by the local color of the object on which the shadow falls, and by the color of the prevailing light. Also, shadows are often tinged with colors complementary (opposite) to the color of the object casting the shadow; for instance, a yellow object may throw a shadow with a blue-violet tinge, particularly on a sunny day when the shadows reflect the blue of the sky.

Another point to watch out for is that shadows vary in density, becoming lighter in shade the further

▷ **Beach Shadow**,
Elizabeth Apgar-Smith, watercolor.
It is not only the colors in shadows that make an interesting painting. Shadows often dominate the composition with their shapes and patterns. Making the shadow the subject of this painting, the artist reduces the backlit figure to a silhouette dancing with its shadow on the sand.

Using oils or acrylics, try painting a shadow made up of patches of various colors, as described right. Roughly paint the ground yellow, the sky blue, and the object casting the shadow red – perhaps a red beach umbrella on the sand. Make the shadow quite large, to give yourself room to make a statement.

The shadow cast by the umbrella on the sand will be made up of patches of yellow and its complementary, violet. Then there will be some reflected light from the red umbrella and some blue reflected from the sky. Paint wet-on-wet and allow the colors to mix but not blend, letting the yellow of the sand show through in places.

Try the same experiment with watercolor. As the sun is shining brightly, the shadow will have a clearly defined edge, so apply the shadow as a transparent wash wet-on-dry. The shadow wash will be made up from the yellow of the sand plus a touch of violet. Then, immediately, while this wash is still wet on the paper, add a minute amount of red and, separately, blue, so that the shadow is not constant in color or tone.

1 The artist has painted the shadow with violet (the complementary color to the yellow sand), with reflected red from the umbrella, and blue from the sky, worked in.

2 Feeling that the contrasts are too high, he has worked a darker ocher tint into the beach area and shadow color and now is adding more red to indicate reflected light, leaving the color unblended on the surface of the shadow.

3 The contrasts are now less extreme and the shadow softer. Light reflected from the surrounding sand bleaches out the edges of the shadow, leaving a darker center. The unblended strokes of color in the shadow area are mixed in the viewer's eye.

EXPERIMENTING WITH SHADOW COLORS
Shadows are rarely constant in shade or color. Reflected light from the sky lightens the outer edges of a shadow, and you may find unexpected colors reflected in the shadow from nearby objects. Shadows also vary in strength and definition according to the quality of the prevailing light.

they are from the object casting them. This effect can be achieved in watercolor by using a tissue to lift out some of the color at the edge of a shadow while the paint is still damp. Train your eye to look for reflected light in shadows; often it is very subtle and barely discernible.

Techniques for painting shadows

To keep your shadows as luminous as possible, paint them thinly and avoid over-blending the colors. With transparent watercolors you can create shadows by first painting the local color of an object, and when this is dry, applying a thin wash of the shadow color over it. For instance, if a tree casts a shadow on a sandy path, the sandy ocher of the path will qualify the superimposed shadow wash and create a lovely resonant color. The shadow wash could be mixed from the original sandy ocher plus a little of its complementary – a violet blue. Soft shadows can be painted wet-on-wet, either graduating the wash from dark to pale or suffusing it with other influencing colors. Hard-edged shadows can be painted wet-on-dry with a series of superimposed washes of slightly varying colors.

With oils and acrylics, wonderfully delicate shadows can be built up with successive tinted glazes. Using the paint opaquely, small patches of the under-color can be allowed to show through the subsequent layers of broken color.

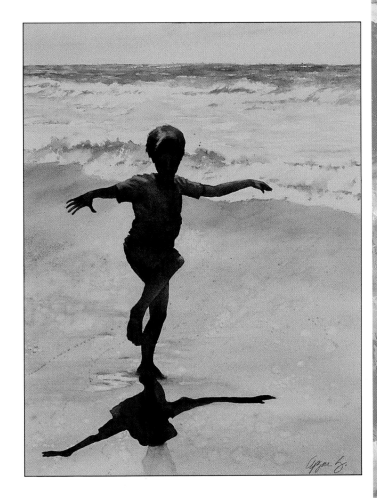

Hot sun

This watercolor painting speaks of the hot Mediterranean sun. The artist was attracted by the geometric pattern created by the strong verticals of the walls, countered by the diagonals of the roof against the sky and the mid-morning shadow cast across the wall. The artist's general plan is to work from cool to warm, starting with blues, through to yellows and finally reds. In this painting the artist is working mainly from memory, but with the aid of a sketch supplemented with notes and photographs.

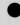

Colors
Cobalt blue
Cerulean blue
Hooker's green dark
Sap green
Yellow ocher
Cadmium yellow
Alizarin crimson
Winsor red
Burnt sienna

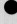

Brushes
Soft round Nos. 3, 7, and 11
Bristle flat No. 7
Small natural sponge for stippling.

Paper
22 × 30in. (57 × 77cm) white
300lb. (630g/m²) Saunders paper.

Palette
The mixing palette used here is a sauce dish placed on some paper towels so the artist can touch the brush on it to remove any excess paint.

Water
The artist recommends keeping your water clean so that the summery colors appear fresh and unmuddied.

1 Having sketched in the outline of the composition, the artist applies masking fluid over those areas which are to be left white, such as the flowers in the foliage.

1

2 With a large softhair brush loaded with cerulean blue warmed with a little cobalt, the artist paints in the sky area and then the shadows.

2

3 A wash of yellow ocher, applied wet-on-dry, runs down further than planned, so the paper is laid flat and a tissue is used to fashion the edge of the step.

3

4

4 Now the artist starts to work on the details, starting from the center of the painting with the foliage. The areas of dried masking fluid mean that a merged wash of dark and light green can be painted in without worrying about the intricate shapes of the flowers and stems.

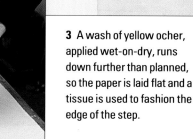

5

5 Further medium areas of shadow are located with diluted cobalt blue, applied with a smaller round brush to give more detail.

6 When the paint is thoroughly dry, the masking fluid is removed by rubbing with a soft kneaded eraser. Note the delicate, darker shadows which have been added to the window panes.

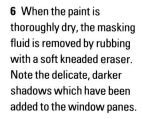

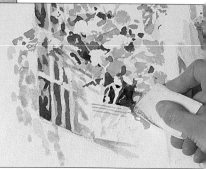

6

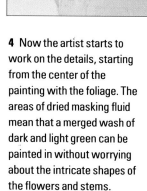

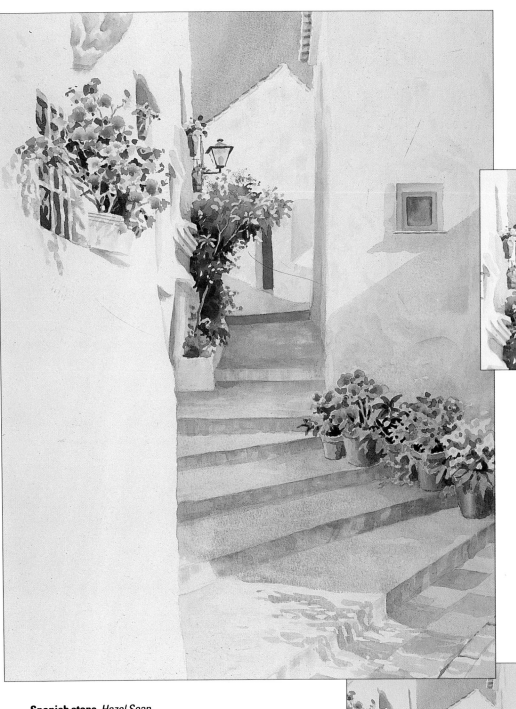

10 Finally, the gabled end of the house is knocked back with a gentle scumble of yellow ocher, applied with a dry brush in a circular motion.

10

9

9 To make the painting "sing," a stronger dilution of yellow ocher is taken through the painting, representing reflected light from the sun. It is applied on the steps here using the drybrush technique with a flat bristle brush.

Spanish steps, *Hazel Soan, watercolor.*
Finally satisfied, the artist declares the painting finished.

8

8 The artist decides that the foliage in the center is too hard-edged, so with a small piece of natural soft sponge she stipples on some green to soften it.

7 The geranium flowers are painted wet-in-wet. First, a pale pink underwash is applied and allowed to dry. It is then wetted with clean water, and a spot of alizarin crimson is added and allowed to fuse and spread.

7

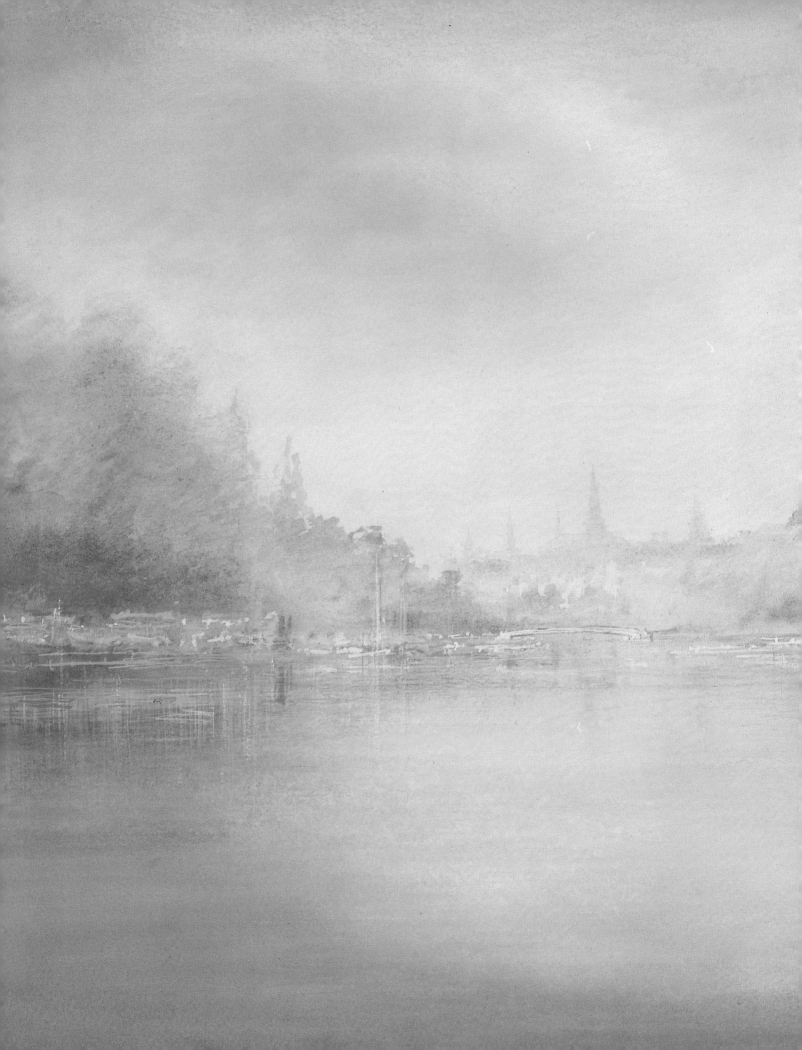

Fog and mist

- **Observing fog and mist**
 Color and tone
 Palettes for fog and mist
 Atmospheric perspective
 Techniques for painting mists
 Demonstration: early morning mist
 In focus: dawn
 Sunlight and mist

Amstel River, Amsterdam,
Paul Kenny, watercolor.
Delicate watercolor tints
applied to dampened paper
produce the tremulous
quality of morning mist on
the canal. The sharp details
of the boats and their
reflections are picked out
with white body color using
a fine brush.

Mists and fogs vary enormously in character and mood and make an excellent study for artists. There are those delicate, early morning mists which promise a hot summer's day; horizontal bands of mist which lie across rivers and reservoirs; swirling mists through which the sun appears briefly, spotlighting rooftops and rain puddles; and thick, choking winter smogs which leave you feeling disoriented.

A mist has the ability to reduce a well-known backyard to a strange, unfamiliar, and alien place. You find yourself forced to concentrate on details closest to you without the context of the background you are accustomed to. This is very unnerving and can lead you to doubt even the most established preconcep-

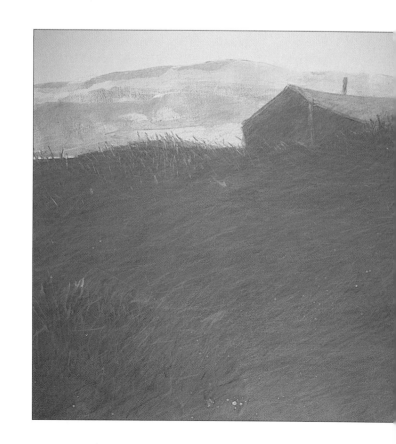

The beauty of misty landscapes is that shapes and shades become softened and blurred, creating a strange, haunting atmosphere

△ **Townscape**, *David Curtis, watercolor.*
The hazy smog of an industrial city has been recorded convincingly in this painting. Soft-toned washes of indigo and raw umber are worked over the whole picture plane, and frail patches of light on the rooftops are rendered with a fine brush. The cranes are understated. The composition is unusual in that the cityscape is seen from a high vantage point.

◁ **Fog Shack**, *Joyce Zavorskas, monotype.*
Monotype is a printmaking process used to create a single impression. Dilute printing inks are smeared or dragged onto a sheet of glass, then worked in with a rag, a sharp tool, or a dry brush. A sheet of paper is laid over this, and an impression of the image is made by burnishing with a wooden spoon or a roller.

tions about your surroundings. Such sensations are bound to interest the artist.

Misty weather acts as a visual filter on our surroundings, turning our perceptions around and creating arcane atmospheres and effects. Colors are starved of their intensity by the enveloping gauze; forms are reduced to silhouettes with soft outlines. This filter also reduces tonal variety and removes

(*Continued on page* 86.)

Summer Evening, Malvern Ridgeway, *David Prentice, watercolor.*
Notice how the artist has modified his colors to suggest rich green foliage in the foreground, paling toward the incandescent haze of a summer day.

Fog and mist studies

These photographs give you some idea of the variation in color and density of mists and fog. As you can see, too, such details will affect the mood of your painting.

◁ Even though this early morning mist appears to bleach the landscape of its color, there is still an eerie light emanating from the sky, enough to cast the reflection of the trees across the water.

◁ A misty sunset off Vancouver Island softens the silhouette of the line of trees. In water-color the sky could be recreated with a variegated wash, with the trees added when the paint is almost dry.

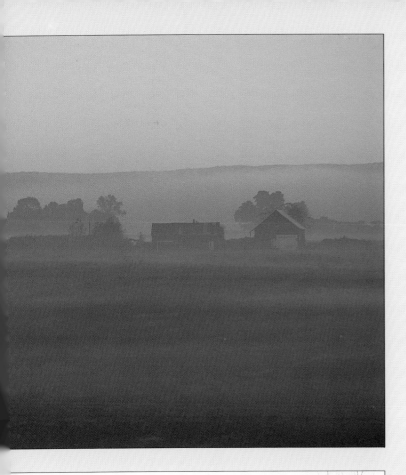

◁ The subtle contrasts created by this early morning mist would be hard to control in any medium. Pre-mixing on the palette to compare shades would help. Because the mist is low-lying, the trees and buildings appear clearer above it, adding notes of contrast.

▽ An awesome L.A. smog, which was photographed without a filter. Although the orange light might appear garish if reproduced, it would in this case put across the alarming nature of this form of pollution.

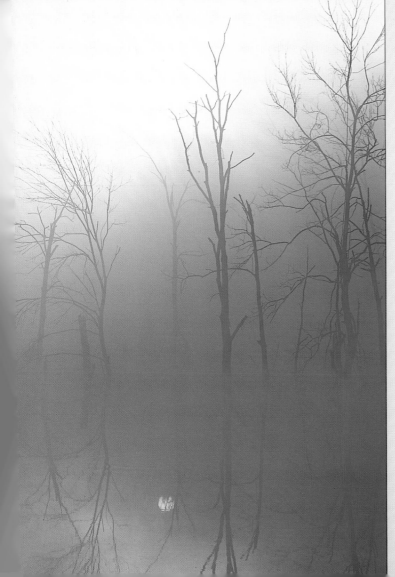

◁ A perfect combination of light, mist, and water, the reflection of the trees adds an uncanny symmetry to this scene. In oils or acrylics, the paint could be worked up with scumbles and drybrush to create the amorphous depths of the misty middle ground.

△ Fog rolling in over the San Francisco landscape creates a dramatic image. Pastels lend themselves to misty scenes. A useful technique would be to fix a first application of blue sky so that the vaporous fog could be scumbled over the top.

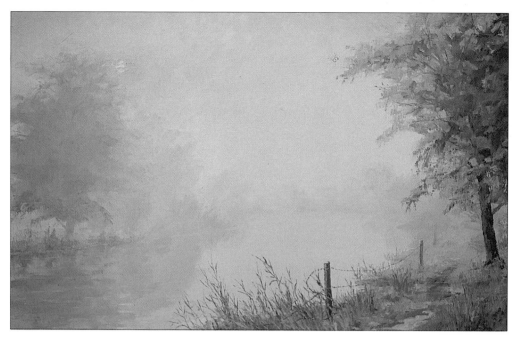

Misty Morning on the Canal,
Brian Bennett, oil.
Veils of morning mist give this landscape an eerie presence, with the forms on the river bank barely perceptible. To achieve this effect, apply your washes with care, allowing some colors to merge wet-in-wet, but also allowing the background passages of the painting to dry before adding the forms in the foreground.

details of texture and outline. You will notice too that the effects of atmospheric perspective are enhanced, and the contrast between foreground, middle ground and background are increased. Forms in the foreground are flattened, reducing them to ill-defined silhouettes. Background elements loom out of the mist, reduced to ghostly shapes floating in space.

Color and shade

There are mists and fogs at all times of the year, and part of the success of painting such weather depends on being able to express the difference between a damp, cold winter smog and an evening mist lit by the setting sun that blankets buildings.

1 A pale Ingres paper is used as a support for this drawing. This type of paper has a "tooth" which helps to retain the pigment on the surface. The colors in the drawing are deliberately restricted to a few related shades.

2 When the basic drawing has been established, a very soft mop brush is used to blend the surface pigment with a gentle feathering motion. This has the effect of reducing the color to a flat stain.

3 This process of applying color and knocking it back can be repeated a number of times, but take care not to damage the surface of the paper. Only the softest brushes should be used.

BLENDING CHALK PASTELS
With experience, you will discover that chalk pastels are as versatile as paint and capable of producing a wide variety of textures and effects. This demonstration shows how far you can push the medium to achieve the results you want. To create the stark atmosphere of a foggy winter day, the pastel pigment is brushed and burnished on the paper to give it a flat, wash-like quality.

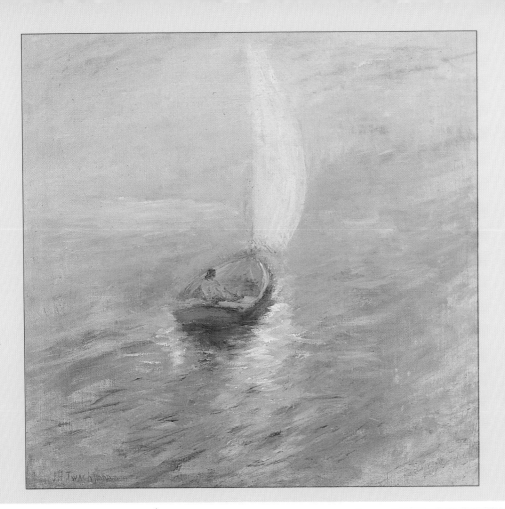

Sailing in the Mist,
John Twatchman, c1895, oil on canvas, 30½ × 30½in. (67 × 67cm) Pennsylvania Academy of Fine Arts.

With subtle shades of cool blue, Twatchman has explored the haunting nature of a sea mist. Caught at the moment before it disappears from sight, we see this small boat and its lonely occupant forging into the unknown. A ghostly source of light illuminates the disturbed water. The depth and silence of the mist has been created by superimposing layers of broken strokes of blue, working from dark to light, over a mushroom-colored ground. In the sky the paint is less agitated and more smoothly blended wet-in-wet. Ripples in the water appear in the unblended brushstrokes of blue with glittering white highlights. The figure in the boat and the boat itself are reduced almost to monochrome.

FURTHER KNOCKING BACK
Now the artist is reducing the contrast of the middle ground with a light layer of white pastel.

1 Darker shades are added to the middle ground, and the plowed earth is suggested by using the edge of the pastel dragged across the surface in horizontal strokes.

2 The contrasts of shade are now adjusted by adding white and ocher to the middle ground. Additionally, the foreground is made denser to heighten the sense of recession. The chalky texture of the sky is left unfixed.

TESTING THE TONAL VALUE OF COLORS
There are more than 500 tints of pastel available, which are made by varying the proportion of white filler to the raw pigment. Try to work initially within a particular tonal range; for instance, for a landscape subject, you might choose a range of ochers, umbers, browns, and siennas.

1 It is useful to leave a border around your work so that you can test colors to see how they compare tonally.

2 This is especially useful in misty scenes where subtle colors need to be matched.

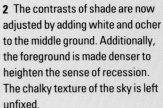

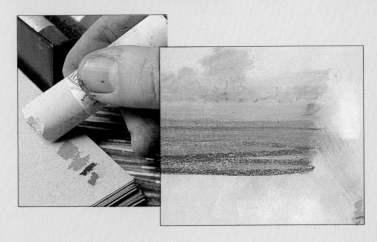

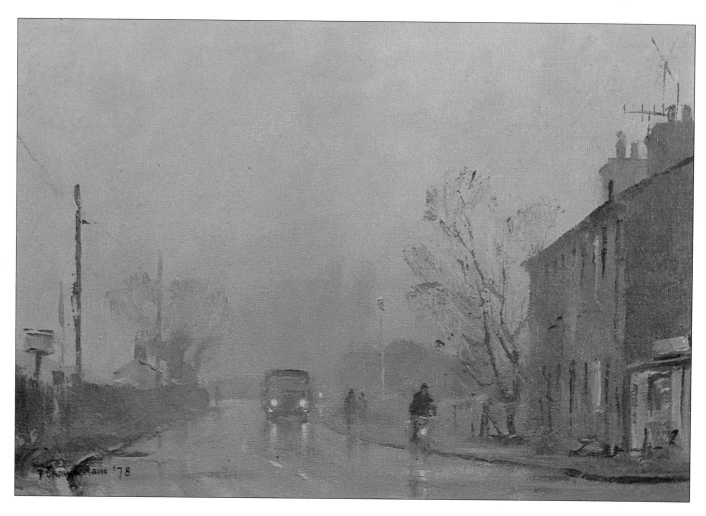

A Damp Foggy Day in December,
Trevor Chamberlain, oil.
Fog has the effect of unifying color and blurring forms in a landscape or townscape; everything is leveled out to a degree where there are no sharp outlines or strong tonal contrasts.

▷ **December River,**
John Plumb, pastel.
This pastel has been produced by an artist who is very much in control of his medium. The monochrome of blue-grays in this pastel painting is relieved by warm shades of reflected light on the surface of the water.

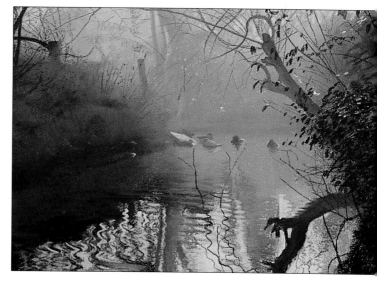

Mist and fog qualify the colors of objects, changing them, rather than just reducing their brightness and making them paler. How precisely a mist affects its surroundings depends on the color of the prevailing light. An early morning summer mist might be a warm yellow or pink; in the winter it would be cooler and bluer; evening mists are often golden. If there are any shadows around, they will contain colors complementary to that of the prevailing light – purples for a yellow light, oranges for a blue light.

On a foggy day the light is soft; there is no direct sunlight, so everything is bathed in a relatively constant middle shade. To capture the softness of the light, keep to a narrow choice of shades, mostly in the light-to-middle end of the scale. Remember that fog makes dark shades appear lighter and light ones appear darker.

When working in oils, acrylics, or pastel, you will find it helpful to work on a toned ground, which helps you to judge the shade and intensity of colors more easily. One ground color that is particularly effective for misty scenes is raw umber diluted to roughly the color of a potato skin.

Whatever the light, you will need to mix your colors carefully in order to achieve the right shade, intensity, and color cast. It helps if you pre-mix the colors in the foreground, middle ground, and background before you start, checking them side by side. With oils, the hues can be compared on the palette.

WATERCOLOR

At first sight this misty scene might appear to be monochrome, but it is in fact made up of superimposed washes of delicately colored grays. You can see touches of blue in the sky, brown madder alizarin in the trees, and yellow ocher in the foreground. Ivory black is a rich black which should be used positively.

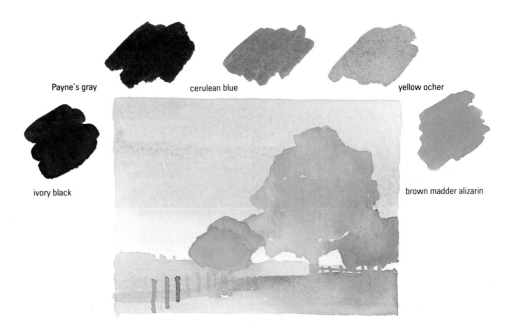

Payne's gray

cerulean blue

yellow ocher

ivory black

brown madder alizarin

OIL/ACRYLIC

A pink light suffuses this misty scene, tempering the grays, which are painted wet-on-dry. The colors in the receding planes become progressively cooler, containing more titanium white plus hints of blue and pale yellow, particularly in the distant trees.

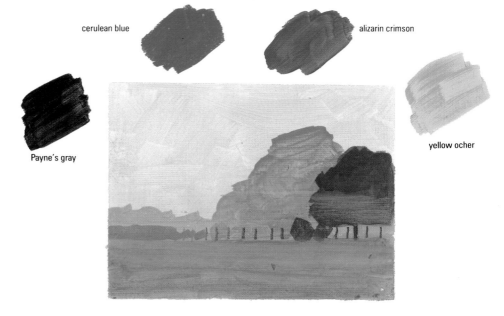

cerulean blue

alizarin crimson

yellow ocher

Payne's gray

PASTEL

The chalky texture of pastels lends itself to misty scenes. Here the effect of dense fog evolves from superimposed scumbles of color, lightened with white. In the sky, yellow ocher is worked over light green gray and over the dark gray, green gray, and purple gray of the trees. In the foreground, light mauve has been lightly worked with a diagonal stroke over blended grays.

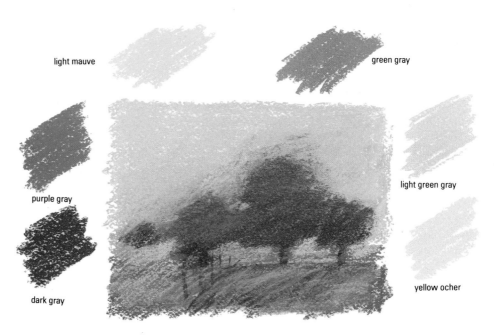

light mauve

green gray

purple gray

light green gray

dark gray

yellow ocher

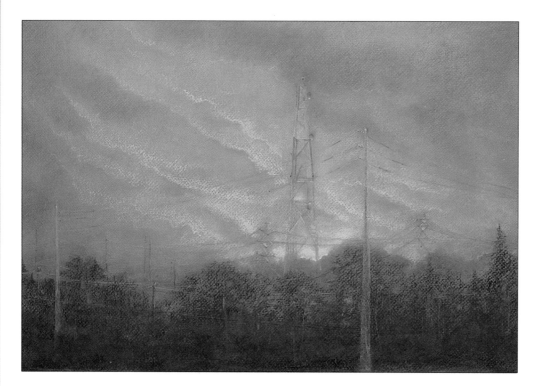

With acrylics you have the problem that the paints dry quickly on the palette, so either use retarder, or spray your palette with a fine mist of water to keep the mixes moist. With watercolors you can test the colors on a scrap of paper (always remembering that they dry to a lighter shade). Some artists leave a border of the sheet that they are working on so that they can experiment with their mixes.

Atmospheric perspective

Mist and fog heighten the effects of atmospheric perspective on the landscape. Foreground, middle ground, and background appear more separate and distinct than normal, and objects only a short distance away seem to melt into a haze. In thick fog, even those forms in the foreground appear almost in silhouette, with few shadows to model their contours. Recession in the picture is achieved through decreasing tonal contrasts, particularly in the background, and by overlapping planes. It's a good idea to start at the horizon with pale, indistinct forms, gradually strengthening the shades as you work toward the foreground – but avoid introducing too much tonal contrast and destroying the illusion of mist. You have to strike a delicate balance.

Techniques for painting mists

Fog and mist are characterized by delicate insubstantial effects, muted colors, and indistinct forms, which need to be treated with sensitivity and a certain deftness; the atmospheric nature of a mist will be lost if the medium is overworked.

Watercolors are naturally suited to representing the transient beauty of mist or fog. The translucence of the medium allows the white of the paper to shine through and create a depth of light which exactly cap-

Dawn of Progress,
Cathy Fontachia, oil-pastel.
This pastel contains a monochrome of blue tints in which the soft forms of sky and landscape are juxtaposed with the stark, linear structures of the electricity towers. The "tooth" of the support breaks up the pastel pigment and contributes an interesting surface texture.

In addition to producing misty effects, this method can also be used to reduce the contrasts of shade in an area of a painting if they are found to be too high, to modify a color, or to enliven an area which has gone "dead."

Using oils or acrylics (the latter will of course dry more quickly), paint a simple landscape scene with "normal" colors. Leave to dry. Then mix white with tiny touches of color – alizarin, ultramarine, or yellow ocher, depending on the prevailing light, and burnt umber or Payne's gray to subdue the color. Using small amounts, brush this dryly over the area, working loosely with random strokes so that the paint qualifies the layer below without obliterating it. The finished effect should be like a haze of smoke, through which the forms of the landscape can be glimpsed.

You may find it easier to achieve this effect if the support is textured. If you do not want to use a canvas, prepare the rough side of a piece of masonite with acrylic primer.

Ashridge: Morning (detail),
Brian Bennett, oil.
A gloomy forest scene in which the leafless forms of the trees echo the vertical dimension of the composition. The paint has been thinned down almost to the consistency of water-color to suggest the mist enveloping the trees, allowing us only a guess at their shapes.

tures misty effects. Allow your washes to flow freely, wet-in-wet, to create swirls of moving mist or receding, nebulous planes. Background forms can be reduced in shade by painting their shapes, allowing them to dry, and then using a natural sponge dampened with clean water to lift out some of the color.

Also with watercolor you can capture the softness of form and color by applying paint to damp paper and allowing the forms to blur at the edges.

The slow-drying properties of oil paints allow you to work wet-in-wet to achieve the appropriate "soft focus" effects. Background planes can be flattened and the outlines softened by a technique called tonking.
(*Continued on page* 97.)

WORKING WET-IN-WET MIST
This technique shows how watercolor on a white ground can be used to create the atmospheric qualities of mist. Make sure you mix enough of the wash in a saucer beforehand, and tilt the board at an angle so that the color flows down the paper.

1 On a sheet of dampened paper, pale washes of rose madder are laid in horizontal strokes, starting at the top of the paper.

2 While the paint is still wet, patches of color are lifted out with a small piece of dampened sponge to reveal the white of the paper.

3 The contours of hills are added, using a wash of cobalt blue mixed with light red. The paper is dampened once more to produce the softly dappled color of the sky and water.

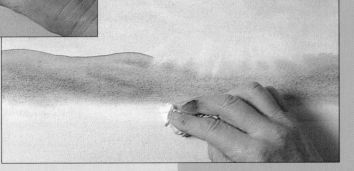

Early morning mist

This painting captures the atmosphere of early morning on a cold, misty spring day. To capture the delicate, hazy effect, the artist begins with a shaded ground of reddish brown which is then overlaid with thin glazes of color. Finally, a hint of texture is added with delicate scumbles, drybrush strokes, and stippling. Acrylics are ideal for this method, as the thin glazes dry quickly, making it possible to complete a painting in one session. The shaded ground, once qualified with a glaze of gray, makes a good medium key against which the subtle shades of the misty background are more easily judged. To emphasize the space between the foreground and the less defined background trees, the artist adds gloss medium to the foreground color mixes so that the paint reflects the light, bringing this area forward.

Colors
Ultramarine
Cerulean blue
Alizarin crimson
Cadmium red
Lemon yellow
Cadmium yellow
Monestial green
Hooker's green
Viridian
Burnt umber
Payne's gray
Titanium white

Palette
The artist uses a pad of disposable paper palettes, which are convenient for outdoor work and dispense with the chore of cleaning off hardened acrylic paints at the end of the day.

Brushes
Nos. 00 and 1 round synthetic brushes. No. 3 white bristle bright. Old, worn, bamboo-handled Chinese brush.

Gloss medium
When using gloss medium, the artist pours a little into the cap of the bottle and mixes it with the paint on the palette. Gloss medium appears milky when wet, but dries transparent.

1 The artist stains the surface of the canvas board with burnt umber mixed with a touch of alizarin crimson. A faithful 20-year-old Chinese brush is used to scrub on the paint until the rather unabsorbent surface accepts it.

2 The artist maps out the horizon, establishing the shade of the light from the sky. The paint is scrubbed on unevenly with a flat bristle brush, working it into the canvas weave.

3 Next the composition is penciled in with a neutral blue crayon. The landscape is charted with dilute, subtle glazes of green mixed from monestial green and cerulean blue, with some white added.

4 Next a background tree is added in a neutral gray, using a fine, long synthetic brush. The definition is blurred with water before the paint has time to dry.

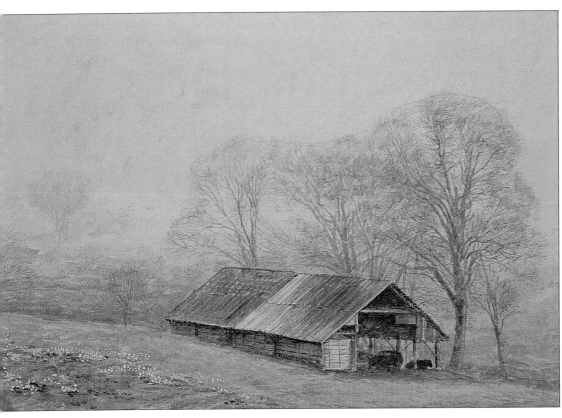

Misty Morning, *Paul Wright, acrylic.*
After some final touches to confirm the various elements of the composition in their proper plane, the painting is declared finished.

8 The artist has built up the greens on this bank and is now stippling on yellow spring flowers with a fine brush.

7 Gloss medium is added to the mixtures used for painting the cow shed in the foreground. This gives the paint a soft sheen, which has the effect of bringing the shed forward in the picture plane. Gentle scumbles of black (mixed from ultramarine and burnt umber) create the corrugated roof.

6 The artist delineates the trees. Care must be taken to get the structure of the trees right. Where the gray seems too strong, it is smudged with the thumb.

5 Now the artist switches to the foreground, building it up with glazes of green mixed from proportions of viridian, lemon yellow and cerulean.

The Big Ben in the Rain,
Doug Lew, watercolor.
The artist, whose work is
seen in more detail
opposite, captures a foggy
day in London using
controlled application of
watercolor washes painted
wet-in-wet.

Dawn

In this feature, we look at a painting in much closer detail, focusing on aspects of the work which solve common problems or are particularly interesting from a technical point of view. The fluidity and natural translucence of watercolor lends itself to the portrayal of misty scenes. Doug Lew here has successfully translated the increasing effects of the dawn mist on the street as it recedes into the distance. He also captures the luminosity of the sky where the sunlight is trying to break through the mist, highlighting the back of the lonely figure and reflecting off the white façade of the house.

△ This figure forms a focus for the painting. The important highlight on the back and on the heel could be conserved as white paper by applying masking fluid at the outset. The background of this detail shows the controlled application of delicate colors wet-in-wet.

◁ Farther into the distance, the contrasts are reduced and the colors bleached. The wet-in-wet application of blurred shapes is superimposed with very pale linear forms wet-on-dry.

◁ ◁ Closest to the viewer, the contrasts are more extreme. Rich shades are built up wet-on-dry, conserving patches of the white paper and picking out details of stones on the road.

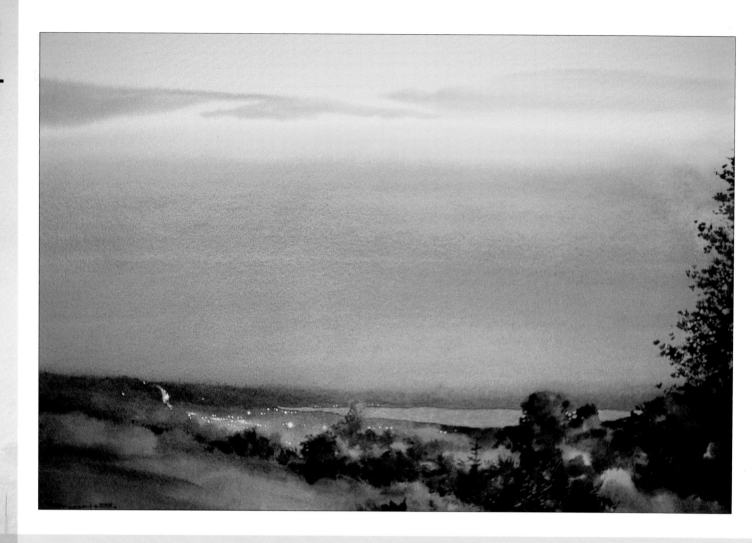

Fog, *Alfred Sisley, 1874, oil on canvas, Musée D'Orsay, Paris.* In this landscape painted near Louveciennes in France, a peasant woman is seen picking herbs in her garden on a misty spring day. The fog has a silvery hue which engulfs the scene, but the pale tints of flowers in the foreground serve to relieve the overall grayness. Sisley's sensitive touch lends a poetic quality to the painting; he has created a sensitive patchwork of pale, subtle colors in a narrow tonal range, and the thin strokes of paint allow the creamy buff ground to show through, suggesting light shining through the mist.

◁ **Dawn**, *Roland Roycraft,*
watercolor.
In this painting the artist has
encompassed a wide
landscape view seen at
dawn before the clarity of
forms is revealed by sunlight.
The sense of isolation and
stillness is heightened by the
large expanse of sky, painted
on damp paper.

▽ **Evening**, *Jack Coggins,*
pastel.
A misty blue light pervades
this scene, qualifying
everything. In the foreground
the contrasts are high and
the colors cooler. A warmer
violet mid-blue dominates
the background.

Lay a clean sheet of newspaper over the wet paint and rub it gently; when the paper is peeled away, it removes with it some of the pigment and softens the outlines. You could also apply layers of paint and then scrape them down with a painting knife to achieve a gauzy effect – perfect for representing delicate mists.

Conversely, the quick-drying properties of acrylics can be used to advantage when painting mists by building up the paint in thin glazes of subtle color, scumbling, stippling, and using a dry brush. Each layer can be left to dry or worked into so that it qualifies the one beneath it to form a shimmering depth of color.

The natural opacity of pastels together with their powdery texture means they are well suited for misty effects. Avoid too much soft blending, however; otherwise, the finished picture will look slick and clichéd. To keep the surface lively, try scumbling a gauzy layer over an underlayer that has been fixed. For background shapes, careful blending with your fingertip or a torchon will produce the flatness of surface required.

Misty scenes are usually peaceful and still, but if you want to introduce movement and drama, leave your brushmarks showing rather than blending them smoothly. In pastels the effect can be captured with vigorous strokes of broken color, without any blending.
(*Continued on page* 100.)

1 The artist has set the tone for his semi-abstract study of city rooftops on a hazy day.

2 A sheet of newspaper is laid over the wet paint and rubbed gently with the palm of the hand. The paper is then peeled away, lifting with it the excess paint and revealing the softened forms of the cityscape.

1 A small amount of dry paint (ocher and white) is loaded onto a small, stiff brush and delicately skimmed over the surface, catching on the tooth of the canvas.

2 The smoke has been worked across the canvas up into the smog-filled sky, uniting the two halves of the painting.

TONKING
The technique of tonking, normally used for rescuing an overworked area of paint, is also excellent for producing soft, misty effects in landscapes.

DRYBRUSH
Loose drybrush strokes convey a sense of movement when painting delicate subjects such as smoke or swirling mist. The underlying color shows through the broken paint, creating a suitably hazy effect.

◁ **May Morning Mist,**
Joyce Zavorskas, monotype.
Cool, neutral colors and a
simple, uncluttered
composition here evoke the
atmosphere of early morning
on a chilly spring day. Rapid,
sgraffitoed marks help to
break up the large expanse
of foreground.

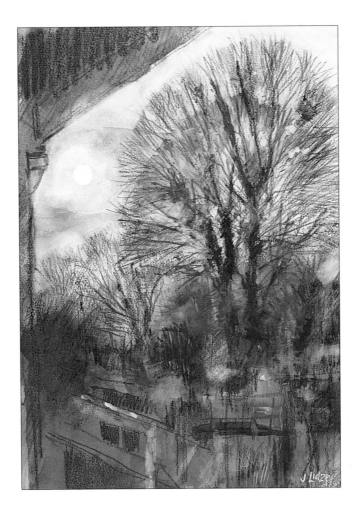

◁ **Misty Sky,** *John Lidzey,*
watercolor.
In this bold composition, the
stark shapes of the trees
counterpoint the misty sky
and water. Charcoal lines
drawn over dried watercolor
washes delineate the upper
branches, while below the
charcoal is smudged into the
wash to soften the forms.

SCUMBLING
A scumble is a hazy "veil" of
pale, dry color applied
randomly over a darker
underlayer and only partially
obscuring it.

A white scumbled cloud of
steam is spread a little with a
brush which has had the
paint taken off it with a cloth.
This suggests catches of
light.

STIPPLING
Subtle, smoky effects can be
achieved by loading dryish
paint onto the tip of a stiff
brush and applying it with a
stippling motion.

1 The smoke from the
chimney stacks is painted
with a stippling motion,
dabbing the brush lightly and
allowing the brushmarks to
remain.

1

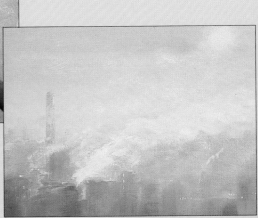

2 In the final picture, you
can see how the stippled
paint adds a subtle hint of
texture to the otherwise flat,
treatment of the scene.

2

▷ **Sketchbook Study,**
John Lidzey, watercolor.
This sketchbook study was made in midsummer in the early evening, and has the freshness and immediacy that comes from direct contact with nature. Lidzey has used a double page of the sketchbook in order to respond adequately to the broadly horizontal forms in the composition. The hazy sunlight is conveyed with loose washes of blue tinged with red and yellow applied wet-in-wet.

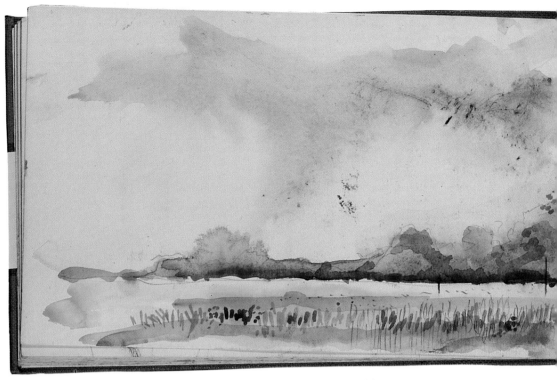

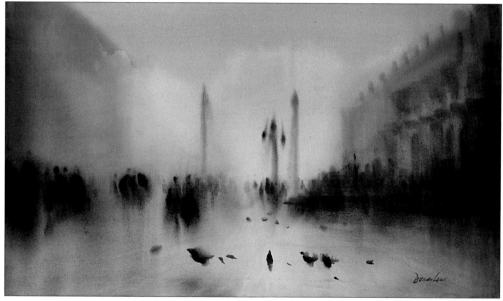

◁ **San Marco in the Fog,**
Doug Lew, watercolor.
There is a great sense of movement in this rapidly executed study. Essentially, washes of two colors – blue and raw umber – are used to convey atmosphere and to hint at the detail of arcaded buildings. The wet-in-wet technique heightens the kind of blurred image one sees in heavy fog.

Sunlight and mist

Light often provides the focus for a painting of a misty landscape. Sometimes the sun shines weakly through a watery haze; other times it actually breaks through the mist and is reflected off water or wet rooftops below.

In watercolor it is possible to lift out some of the paint with a sponge or a piece of crumpled tissue to create an impression of shafts of watery light streaming down from sky to land. The sparkling reflections of light on a stretch of water or on roads and rooftops may be left as areas of untouched white paper to give them special brilliance; these areas can be protected at the start with masking fluid, allowing you to sweep in wet washes for the misty areas without having to worry about working around the white shapes. When the painting is dry, the masking fluid is rubbed off to reveal the preserved white paper below.

Another useful technique is drybrush, in which a small amount of color is picked up on the brush and skimmed lightly over the surface of dry paper. The paint catches on the raised tooth of the paper and leaves a broken stroke that resembles touches of dancing light on water.

Turner was particularly drawn by the lyrical effects created by the combination of sunlight, mist, and water. His sketchbooks contain many watercolor studies of Venice and of castles on lakes and rivers, all enveloped in a shimmering mist. They are worth studying for his expressive use of the medium in capturing the poetry of light.

Trees + fields Wortham / Magpie Lane. 2nd August 88. 6pm Hazy sun

▽ **First Light, September**,
Trevor Chamberlain, oil.
This painting captures the
moment when early morning
mist rises to reveal a
landscape illuminated by
weak autumnal sunlight. All
the tones are understated –
the artist has neutralized the
colors by adding flake
white. The sense of rural
calm is enhanced by the
harmonious colors and
smooth, broad brushwork.

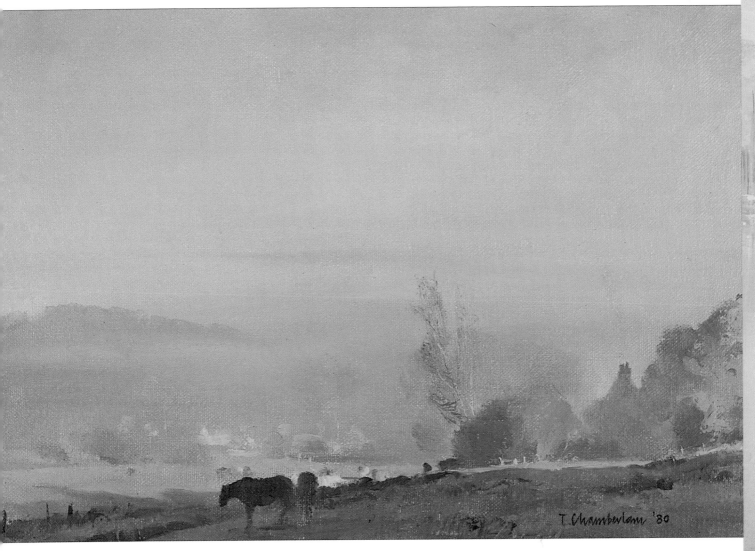

T. Chamberlain '80

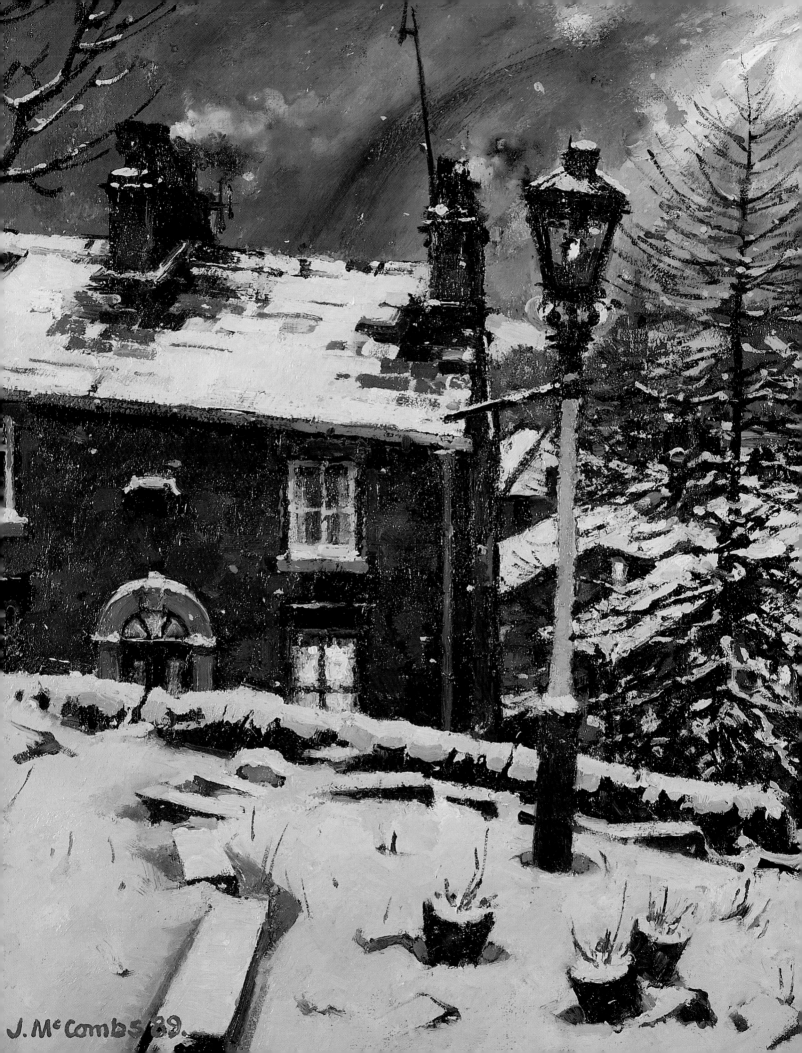

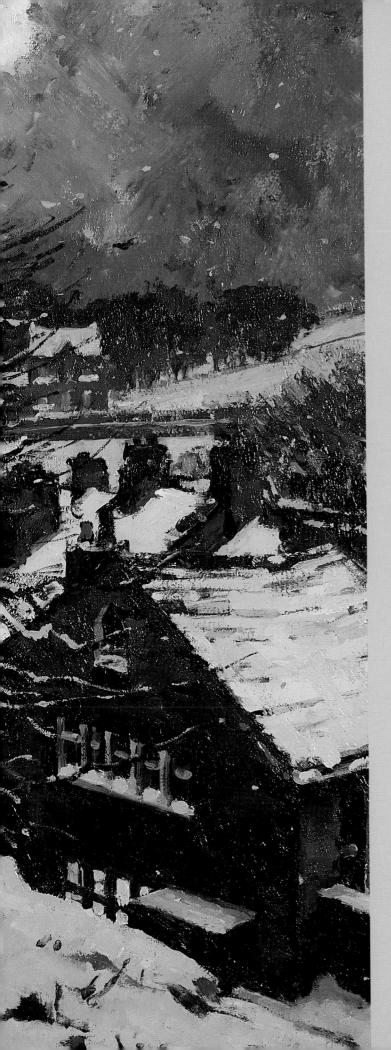

Snow

Late Afternoon, Midwinter, Delph, *John McCombs, oil.* This painting shows how snow dramatically transforms the tonal relationships of a landscape. The snow also reveals forms in the foreground which might otherwise remain unseen. In this essentially monochromatic painting, the warm, colored light of the interior of the cottage is isolated and emphasized by the surrounding hues of cool gray.

f or those who rarely see snow and regard it as a treat, it is a sight that brings pleasure and excitement. For others it betides the onset of long weeks or months of cold and discomfort, so they greet it with a less positive attitude. As in all paintings of weather, the artist's emotional response to the subject is at least as important as the presentation of the facts. And it is not only moods that have to be recreated, but sensations such as cold and wet as well.

No wonder there are many who are intimidated

Heavy snow-filled skies and crisp frosty mornings have their own special atmosphere, which you can readily capture in paint

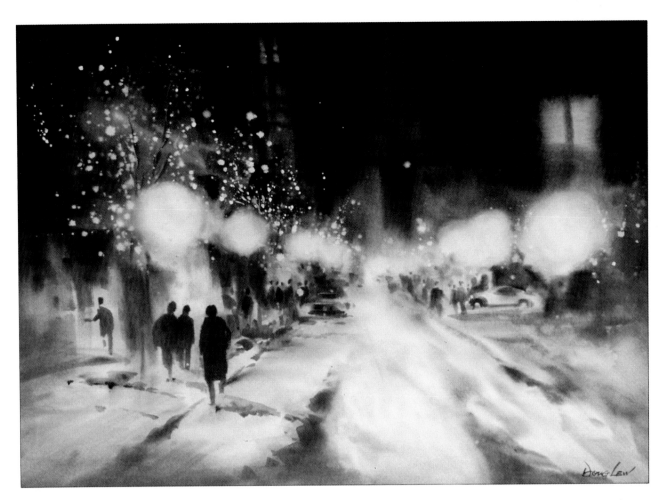

◁ **Sinaia, Carpathian Mountains, Romania,**
Ray Evans, pen and ink and watercolor.
This sketchbook study has a conviction and freshness that can only come from working from direct observation. The white of the paper has been used to great effect.

Nicollet Mall at Night,
Doug Lew, watercolor.
In this night scene, the light emanating from the street lights, tree lights, cars, and stores radiates from the center of the composition. The dark sepia background reveals the stark forms of buildings which are barely perceptible.

by the prospect of painting snow. They feel unable to cope with such an expanse of white, and sub-zero temperatures do not exactly encourage them to take their paints outside to try. But even if you demur from braving the elements in order actually to paint, you can sketch a scene from the inside of a car, or simply take a walk and observe your surroundings with an artist's eye. Certainly it is worth studying at first hand the effect that snow has on the landscape and, particularly, the effect of different kinds of light on the snow itself. Getting closer to your subject in this way, you will soon discover that snow is a fascinating subject.

Mixing snow colors

If you have ever woken up in bed when there is snow outside, you will know how the room appears bathed
[Continued on page 108.]

Snow and ice studies

The artist is at an advantage over the photographer when it comes to snow scenes, because the subtleties of reflected light and colored shadows are often lost in the photographic process.

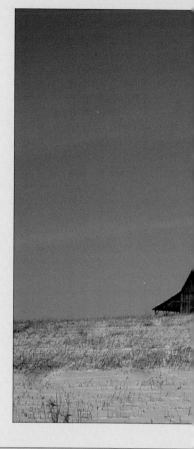

▽ Bright sunshine throws up the contrasts of this dramatic mountain scene. Note how the snow reflects the blue of the sky in the shadow areas.

▷ The mood of this composition could be greatly enhanced by the use of cool colors to emphasize the wintry isolation of this silhouetted barn.

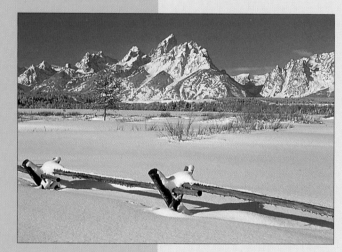

▷ A snowstorm on the freeway could be enlivened by the creative use of paint. Techniques such as spattering, drybrush, and sgraffito could translate into paint the drama of such a storm.

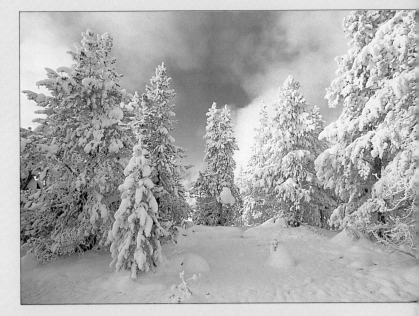

▽ This Colorado sunrise creates a dramatic spread of color along the horizon line. The luminosity of the foreground snow could be recreated with transparent glazes of color.

▷ In watercolor, the intricate highlights of these snow-covered trees could be preserved as white paper with the skillful use of masking fluid before adding the paint.

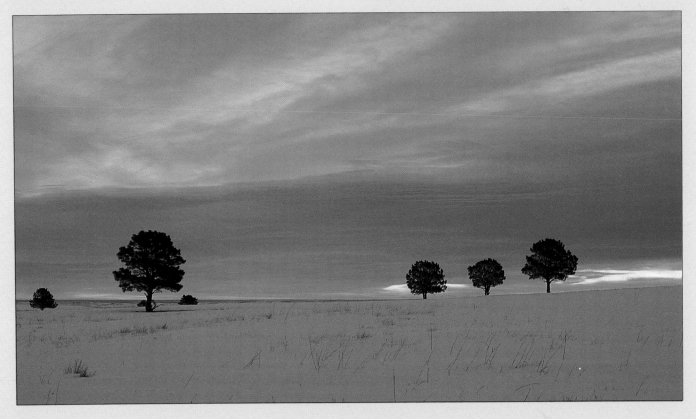

Ashridge Winter,
Brian Bennett, oil.
This painting demonstrates how light reflected on a snow-covered landscape can illuminate the whole scene. There is a careful balance of warm and cool colors, which are held together by the skeletal forms of the trees on each side of the composition.

▷ **Warm Winter Tones**,
Margaret M Martin, watercolor.
Watercolor is the ideal medium for conveying the feeling of a rapid thaw that is evident in this painting. Notice how the warm stucco color of the houses is reflected in the pools of water at the edge of the road. The brightness of the scene is defined by well-controlled washes.

in a cool light. This is because snow, being a highly reflective surface, reflects light from the sky in the same way that a body of water does.

For this reason, snow is rarely a blanket of pure white; its color is affected by the quality of the prevailing light. For instance, on a sunny day the sunstruck areas of snow appear dazzlingly white, but the yellow sunlight produces shadows which contain its complementary color – blue or blue-violet, depending on the warmth or coolness of the sunlight. Warm evening light creates softer highlights, often with a yellowish or pinkish tinge, and deep blue shadows.

When painting in oils and acrylics, you will find that titanium white is the best for painting snow as it is

strong and opaque and has good covering power. To modify the white, add hints of yellow ocher (warm) or lemon yellow (cool) for the light-struck areas, and cobalt blue and alizarin to mix the blues and grays for the shadows. Remember that white acquires color very rapidly, so add the hints of color carefully, a touch at a time. Use a thicker impasto in the light-struck areas, so that it catches the light.

In transparent watercolor you have to establish the position of the brightest highlights on the snow in advance and paint around them. Or you could try working on a toned paper and adding body color (Chinese white) to the colors. The slight chalkiness of Chinese white renders the appropriate powdery effect of snow.

1 A small quantity of masking fluid is lifted from the saucer with an old toothbrush.
2 The loaded brush is dragged against the edge of a palette knife so that flecks of masking fluid are spattered onto the surface of the paper and allowed to dry before overpainting.

SPATTERING
The use of the spatter technique is usually restricted to small areas in a painting, to enrich texture or to enhance atmosphere. Use newspaper to mask off those parts of the painting that are not to be spattered.

LAYING AN IRREGULAR WASH
Watercolor washes laid on dampened paper have a soft, diffused quality, perfect for capturing the effect of filtered light.

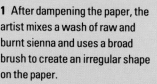

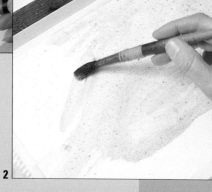

1 After dampening the paper, the artist mixes a wash of raw and burnt sienna and uses a broad brush to create an irregular shape on the paper.
2 The paint is broken by the now dry droplets of masking fluid.

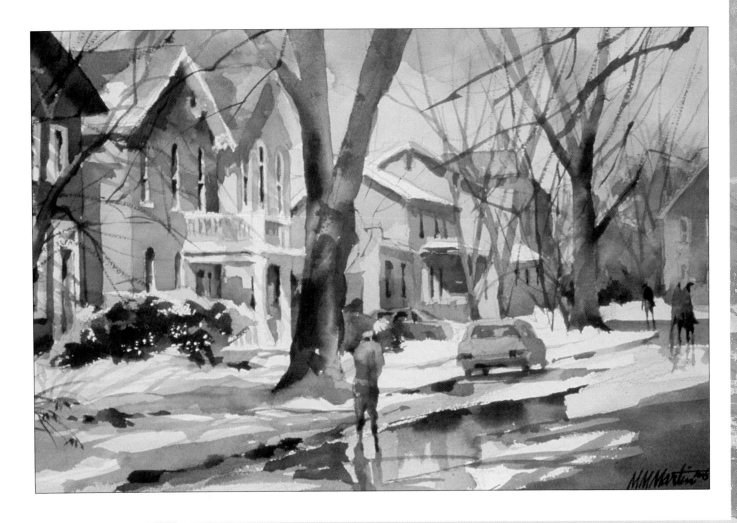

LIFTING OUT

The technique of lifting out can be used to soften edges and to reveal washes beneath washes. Use a sponge, paintbrush, or soft tissue, and a gentle dabbing action to remove paint.

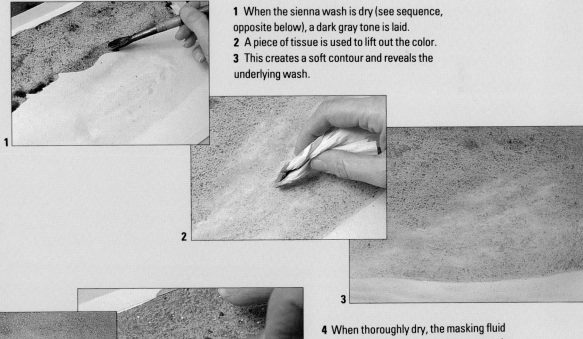

1 When the sienna wash is dry (see sequence, opposite below), a dark gray tone is laid.
2 A piece of tissue is used to lift out the color.
3 This creates a soft contour and reveals the underlying wash.

4 When thoroughly dry, the masking fluid (applied in the sequence, opposite above) is removed. This is done by gently rubbing with a fingertip or kneaded eraser, taking care not to damage the surface of the paper.
5 With the masking fluid removed, the white of the paper is revealed as speckled snowflakes seen through color washes.

The Magpie,
Claude Monet, 1866–8, oil on canvas, 34 × 50in. (89 × 130cm), Musée d'Orsay, Paris.
Monet uses mainly cool colors here to indicate the sharp cold of a winter morning in deep snow. It is the juxtaposition of the complementary colors yellow and violet which gives this painting its freshness and conveys the luminous quality of the light under such conditions. These colors are woven throughout the painting in a wide range of tints: in the sky, very pale, in the foreground snow as minute touches of pure color. The striking shadow cast by the fence is built up and roughly blended in violets, dirty pinks, yellows, and cool blue-grays.

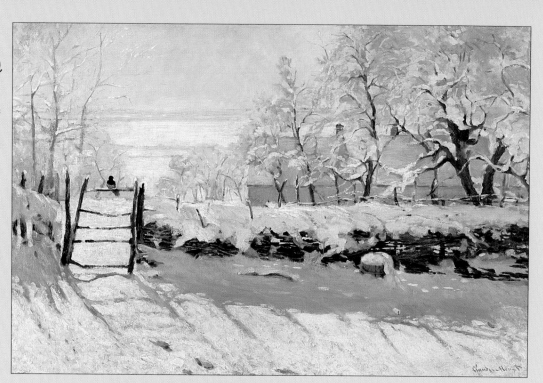

The Clearing,
Roland Roycraft, watercolor.
This is a well-composed landscape using carefully controlled washes of color. The undulating landscape forms in the foreground and middle distance are suggested by a single wash of cerulean blue. Reflections of the trees in the water, and their shadows on the snow are registered with a wash of burnt umber. A distant bank of snow in sunlight is defined by warm washes of color on the horizon.

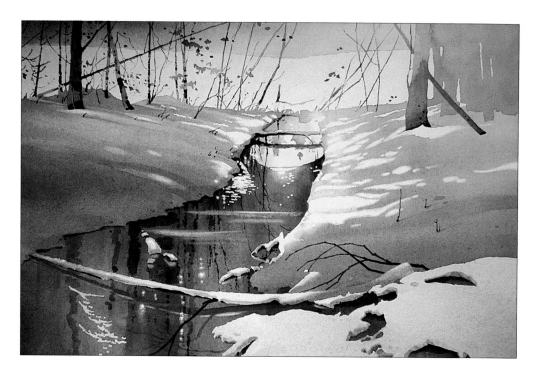

When the sky is overcast, the snow may appear very white by contrast, but closer inspection will reveal hints of creams, grays, and browns. Good grays can be mixed from white, yellow ocher, and raw umber or white, ultramarine, and raw umber. Vary the balance of these mixes to create a variety of interesting grays.

Once you have discovered the range of colors to be found in "white" snow, you will never look back. On snow, all these purples and blues and yellows achieve an intensity and palpable vibrancy which is very exciting to paint. Look at these colors in Monet's snow scene, shown above. The light comes from a watery sun in a pale sky. But note that even though the sky is pale, it is still tonally darker than the snow. The shadows in this painting are a rich tapestry of purple, pink, and blue, juxtaposed with complementary flecks of yellow and orange reflected light in the snow. The painting succeeds in capturing the intensity of the light and the

WATERCOLOR

The dark stormy sky contains a wash of pale gray suffused with darker grays wet-in-wet. The basic mix is cerulean, brown madder alizarin, and Payne's gray, with a touch of ivory black. The snow shadows are mixed from cerulean and brown madder alizarin. Create snow flakes by conserving the paper with masking fluid, or add them afterward with body color.

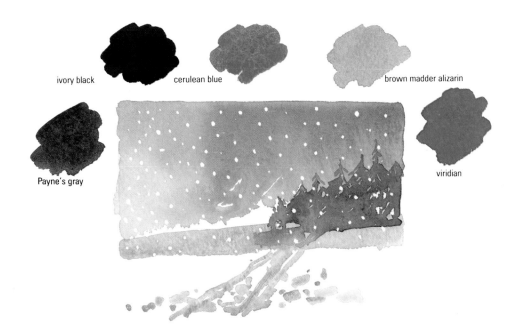

ivory black

cerulean blue

brown madder alizarin

Payne's gray

viridian

OIL/ACRYLIC

Directional brushwork in the sky captures the movement and drama of this snowstorm. The sky consists of Payne's gray, titanium white, and yellow ocher, with a touch of cadmium red toward the horizon. The snow shadows are mixed from cerulean blue, viridian, and yellow ocher. Exaggerated snowflakes are added individually at the end.

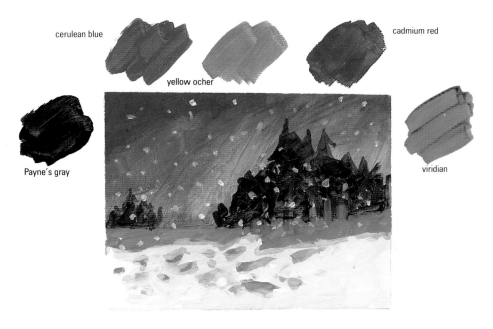

cerulean blue

yellow ocher

cadmium red

Payne's gray

viridian

PASTEL

Bold contrasts give zest to this little snow scene. Scumbles of Prussian blue, light blue gray and white build a rich stormy sky, dotted with white to hint at falling snow. Warm blue snow shadows hint at the suddenness of the encroaching storm.

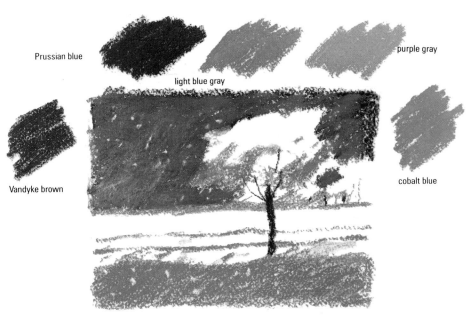

Prussian blue

light blue gray

purple gray

Vandyke brown

cobalt blue

1 The trees in this alpine scene are lightly drawn in black pastel, which is broken up by the grain of the pale gray Ingres paper. The black provides a tonal key for the rest of the drawing.

2 A dark purple-gray pastel is added to the branches and trunk of the tree. Shadows are indicated with a pale violet tint, using a soft pastel. In snow scenes, shadow colors are generally denser close to the object which casts them. Reflected light reduces their intensity toward the edge of the shadow.

3 The artist now consolidates the shadows with a darker shade of deep violet at the base of the tree.

4 The shadow at the base of the tree is modified with touches of pink and pale blue, reflected from the sky. The contrast is heightened by working white pastel into and around the shadow.

5 The shade of the snow on the branches is moderated with patches of pale blue reflected from the sky.

6 The pale blue tint used for the sky is worked around the branches, defining the shape of the tree and increasing contrast. Finally the effect of sunlight is created by adding touches of yellow ocher and blue to the snow in the foreground.

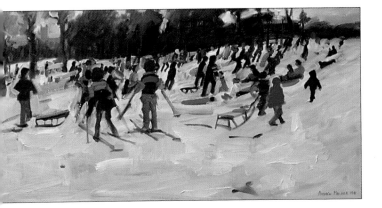

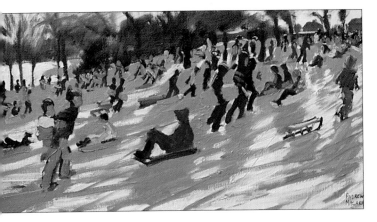

Sledging Derby,
Andrew Macara, oil.
Here we see the same scene under two very different qualities of light. In the first composition, the sun is low in the sky, and the monochrome of distant trees and silhouetted figures is relieved only by small patches of color. In the second, we can see that brighter sunlight produces sharper contrasts of tint and color. The blue shadows unify and complement the bright colors of the sleds.

cold through the careful balance of muted colors applied in small dabs to create a shimmering effect.

Hard and soft edges

If you look at shadows in the snow, you will notice that in bright light they are crisp-edged and noticeably darker near the objects casting them, but paler and more diffused further out. This is because of reflected light which is "bounced" into the shadows from the snow. To recreate this effect, gradually lighten the shade of your shadows near the edges, and softly blend the edges into the surrounding snow color with wet-in-wet strokes. Keep the shadows delicate and airy by using thin washes and glazes of color.

Planning your picture

In order to capture the spirit of winter, you will need to plan your picture and decide what kind of mood is conveyed by the prevailing light. For instance, on a bleak, overcast day, you may wish to emphasize the lonely, cold, dark mood. The whole tonality of the landscape is altered: the sky is a darker shade than the snow, and there are no strong shadows or highlights –
(Continued on page 116.)

One Last Ride,
*Elizabeth Apgar-Smith,
pastel.*
Strongly linear shades of warm and cool pastel tints help to create the feeling of a sunlit snowscene in which the surface of the snow has become deeply rutted and scarred by skis and sleds. A diagonal line of shadow links the figure in the foreground to the distance, and to two other figures on the horizon about to descend the hill.

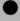
Snowy morning

The artist who painted this snow scene works outside at every opportunity and has therefore built up an encyclopedia of knowledge about nature and her wondrous ways. Producing a step-by-step painting out in the snow was not practical, so the artist used a photograph as reference, drawing on his visual memory and experience to supplement the basic record of the facts. His method first of all was to map out the main areas of tint with paint thinned with oil, gradually increasing the thickness of the paint as the painting progressed. Because it is usually so cold when there is snow on the ground, he used a small canvas board which could be covered quickly.

Colors
Ultramarine
Cobalt blue
Alizarin crimson
Indian red
Cadmium red
Cadmium orange
Indian yellow
Yellow ocher
Burnt sienna
Raw umber
Burnt umber
Terre verte
Ivory black
Titanium white

Brushes
The artist chooses from a selection of around 20 brushes in a choice of sizes and types – rounds, filberts, and brights, bristle and softhair – which he holds in a bunch in his hand.

Palette
An oblong wooden palette with metal dippers for oil and turpentine attached.

Support
A small canvas board prepared in the traditional way with rabbit skin sizing and an absorbent ground of egg oil emulsion.

1 A ground of egg oil emulsion has been tinted with a dilute watercolor wash of ultramarine and cadmium red, applied with irregular strokes. The composition is then mapped out with burnt umber.

1

2 The artist gently fills in the main areas of shade with a bristle brush. Here, with a medium blue mixture, he begins to plot the areas of snow shadow.

2

3 For the snow on the bridge, thick white paint tinted with a little alizarin crimson is applied with a No. 3 round soft brush. No attempt is made to blend the paint or to cover the pinkish ground which gives depth to this area.

3

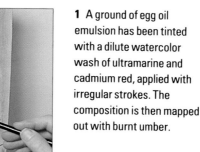

4 Snow is added to the branches of the trees with a dilute mixture of pale blue-gray.

4

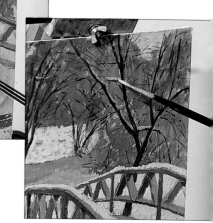

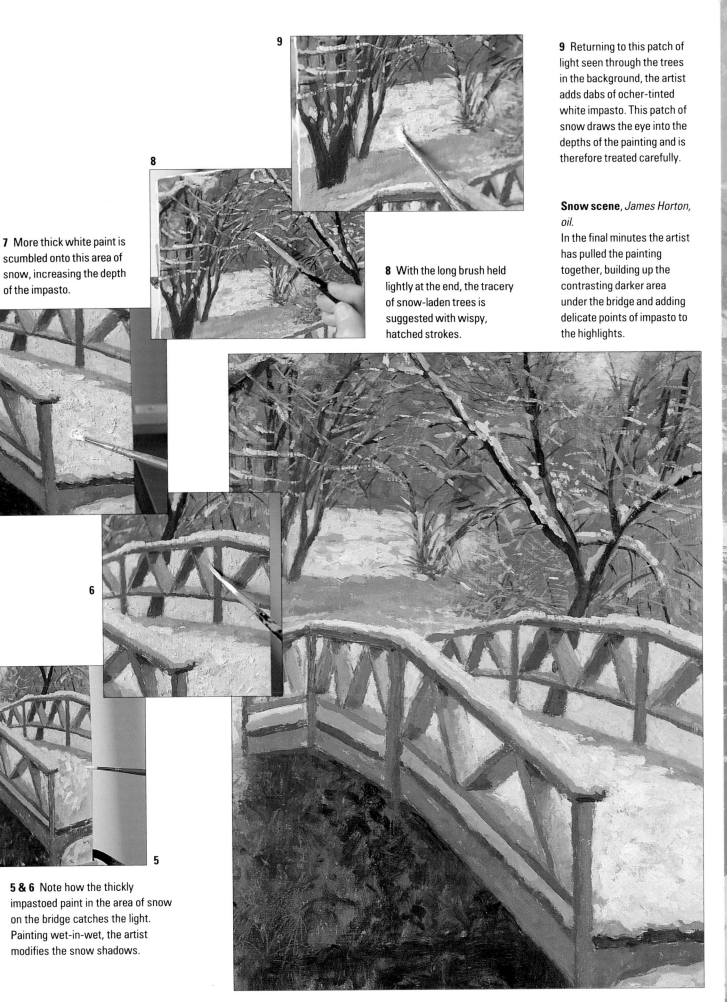

9 Returning to this patch of light seen through the trees in the background, the artist adds dabs of ocher-tinted white impasto. This patch of snow draws the eye into the depths of the painting and is therefore treated carefully.

Snow scene, *James Horton, oil.*
In the final minutes the artist has pulled the painting together, building up the contrasting darker area under the bridge and adding delicate points of impasto to the highlights.

7 More thick white paint is scumbled onto this area of snow, increasing the depth of the impasto.

8 With the long brush held lightly at the end, the tracery of snow-laden trees is suggested with wispy, hatched strokes.

5 & 6 Note how the thickly impastoed paint in the area of snow on the bridge catches the light. Painting wet-in-wet, the artist modifies the snow shadows.

1 A mixture of Payne's gray, cerulean blue, yellow ocher, and white is scrubbed onto the background with a decorator's brush. This technique creates the impression of a somber winter sky.

BUILDING UP A BACKGROUND
Acrylic paints provide the artist with a versatile medium. They are diluted with water, can be used in varying consistencies from transparent washes to opaque shades, and they dry rapidly. Additionally, they will adhere to almost any support.

2 The horizon is roughly defined using white/gray shades broadly brushed across the lower half of the composition, merging into the sky where the tints meet.

3 In order to create the impression of a fall of blown snow, some of the paint is lifted off with a tissue, following the direction of the brushstrokes.

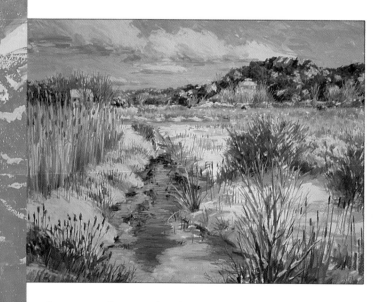

just neutral tones that flatten everything. Against these delicate middle shades, the dark, skeletal shapes of the trees stand out in dramatic contrast.

At the opposite end of the scale, what could be more exhilarating than a snowscape on a fresh, sunny morning under a sparkling blue sky? Here you can revel in the colorful contrasts between creamy highlights and cool blue-violet shadows in the snow, each intensifying the other. Later in the day, the mood changes again with the sun low in the sky casting long, deeply colored shadows and picking out hints of gold.

Finally, there is the sheer magic of thick snow-

flakes falling to the ground, muffling sounds and creating a hushed, still atmosphere.

Capturing the sensation of cold

A test that could be set for all paintings of winter scenes is: "Does it make me shiver?" One way of making sure that you get across the sensation of cold is to get out there and experience it.

Painting the scene from life (wearing multiple pairs of socks and gloves) will remind you that the temperature is an important part of painting such weather. Even so, it can be difficult to capture in paint such an intangible feeling as "cold," particularly if it happens to be a cold, but sunny, day.

In order to portray the sun, the snow, *and* the cold, you will have to learn to manipulate what you see before you. First of all, choose your viewpoint carefully, perhaps including the blue sky, but tempering it with a lattice of bare trees. Overplay the areas of shadow compared with the patches of sunlight. If you include figures, use "body language" to demonstrate how they feel – hunched up against the cold, rubbing their hands, or with them stuffed deep in pockets, muffled up in wool scarves, hats, and gloves.

Perhaps the most important tool the artist has in influencing such sensations is color, and this in turn is influenced by the light. A cold winter sun will not be strong, but quite watery, casting a pale yellow light with cold, blue shadows. And because the sun is lower

TECHNIQUES FOR CAPTURING SNOW

With the scene having been set in the sequence on the left, this demonstration (right) shows a group of techniques for capturing falling snow as it is whipped across the brow of the hill.

1 Having built up the background (see opposite), trees are painted on the horizon. The trees are blurred by brushing over them with water while still wet. The blown snow in the center is given a similar treatment.

2 The effect of a snowstorm is created by spattering alternate shades of white and gray over the painting with a 1in (2.5cm) decorator's brush.

3 Using the same brush, another layer of white pigment is dragged over the surface of the painting. The impasto of the snowstorm is sanded with a piece of fine sandpaper to add to the sense of whipped-up, powdery snow.

◁ **Heart of the Winter, Corn Hill**, *Simie Maryles, pastel.*
A light covering of snow is broken by reeds and grass, producing a harmonious relationship of color which is also reflected in the sky. The pastels are used in broad, painterly strokes, bringing a coherent visual unity to the composition.

▷ ▷ **Hayrolls**, *Paul WE Andrus, pastel.*
Here the same subject has been recorded at different times of the day, and in both a vertical and horizontal composition. In the first drawing, there is an equal distribution of shading between the snow in the foreground and the warm shades of the hayroll and sky. In the second drawing, the shades of the landscape and sky are more equally balanced and are linked by a group of low-lying buildings.

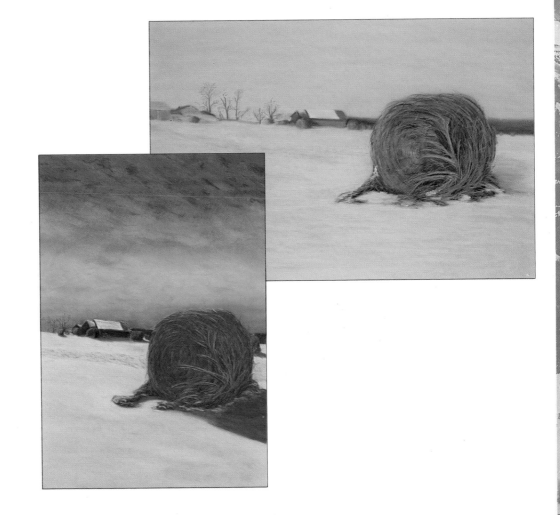

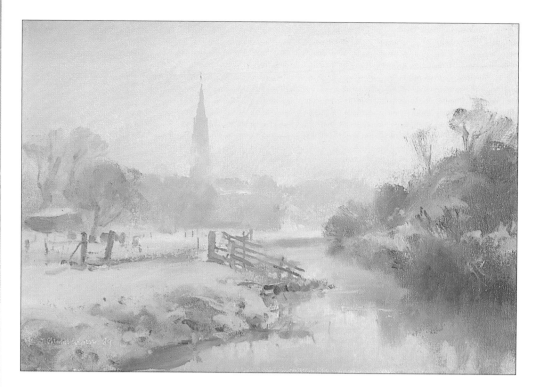

Dawn Frost, Hertford,
Trevor Chamberlain, oil.
This small study is intensely atmospheric and evocative of a landscape in the grip of a severe frost. A distant haze is punctuated by the spire of the cathedral, which is the focal point of the composition. Frost produces a landscape scene that is more subdued and with less contrast than a snow-covered view.

in the sky in winter, it casts longer shadows than in summer.

You will find that by playing on the cool side of all your colors, the temperature of the painting can be manipulated. Use cool blues for the sky and in the shadows – those with less pink in them and more yellow, such as cobalt and cerulean. With yellows, veer toward cool lemon or chrome rather than ocher or cadmium. Although it might seem like a contradiction in terms, you can have cool reds, too – blue reds such as alizarin crimson rather than pink reds.

Another excellent way to emphasize the feeling of coldness in your painting is by introducing small touches of warm color, which has the effect of intensi-

To see for yourself the effect of using warm and cool colors, set yourself up to paint a simple snow scene in two versions. Make it a sunny day so that you can wax lyrical with your shadow colors.

In your first painting, exaggerate the warm side of the colors you are using – the reds, yellows, and oranges – even in the grays. Lay them down broadly, just giving the gist of the scene. Now, repeat the scene with the same strokes and colors, but this time using cooler versions of those colors, playing up the blues, greens, and violets in your mixtures.

Now compare the two paintings. Which one is more effective in capturing the atmosphere of a cold day?

Pennsylvania Farm,
Bryn Craig, oil.
This backlit scene has a strong tonal unity. The closely knit, cold gray colors of the farm buildings are silhouetted against the warmer and brighter shades of the sky. A light glowing in the farmhouse is reflected on to the snow, creating a sense of anticipation and mystery.

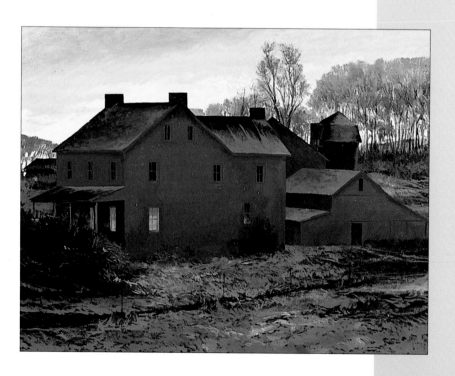

Crisp, trodden snow

In this feature, we look at a painting in much closer detail, focusing on aspects of the work which solve common problems or are particularly interesting from a technical point of view. Working on coarse-textured paper, Dennis Roxby Bott has carefully built up this watercolor with flat washes applied wet-on-dry. The texture of the crisp, trodden snow is further enhanced with spatterings of dilute paint, which break up the solid whiteness of the paper, representing the highlights of the snow.. Reflections of a blue sky overhead are seen in the snow shadows and also in the shiny bodywork of the car.

△ Background snow shadows are reduced in shade. The trees are carefully painted in, blotted where they appear too stark and built up with overlaid washes to increase tone. A spatter of tree color bonds the linear frieze of trees.

△ The snow on the car could be preserved as white paper using masking fluid. Extra surface interest is added to the car by applying wet strokes and washes over previously dry ones.

△ Closer inspection of this area reveals how carefully these small superimposed patches of paint have been placed.

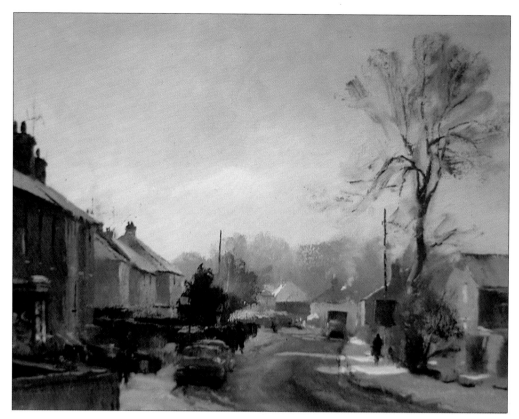

◁ **Winter Morning, Hertford,**
Trevor Chamberlain, oil.
A pallid winter sun filters
through snow clouds to
illuminate this rural scene.
The warm sshade of the
buildings is seen in
harmonious contrast to the
snow-covered road and
sidewalks.

▽ **Sled Dog Race,** *Doug Lew,*
watercolor.
This rapidly-executed
watercolor sketch conveys
a sense of speed and
exhilaration. The form of the
figure, and the dogs pulling
the sled, are softened by
painting wet-on-wet. By
restricting the washes to a
predominant blue, the white
of the paper plays an
important part in defining the
main area of snow.

fying the cool colors. For example, play up the effect
of sunlight on the warm red of a distant rooftop, or
include one or two figures in bright clothes. Alterna-
tively, you might try working on a tinted ground of a
warm earth color, allowing the underlayer to show
through in places.

Painting falling snow

Like fog or mist, falling snow creates a veil of white
over forms and colors. It reduces visibility, cutting out
much of the detail in background objects and bleaching
out their tones and colors.

Snowflakes will show up against darker forms
and can be laboriously painted on with a small brush
after the scene is completed. Alternatively, you can
scratch back with a scalpel to the white ground. But
with these methods, it is sometimes difficult to achieve a
naturalistic flurry of snow.

With paint media, spattering is an effective
technique for rendering falling snow. In watercolor
painting, use either Chinese white or white gouache,
mixed to a thick but fluid consistency. Load the paint
onto a small, stiff white bristle decorator's brush or an
old toothbrush, hold it at least 4in. (10cm) from the
paper, and draw your thumb back across the bristles to
release a shower of fine droplets.

It is always a good idea to practice on some
spare paper before you tackle your painting, adjusting
the dilution of the paint, the pressure on the brush,
and the distance between brush and paper until you
perfect the size and density of spatter you want.

Take care not to overdo the spattering – a little
is more effective than too much. If you want to create

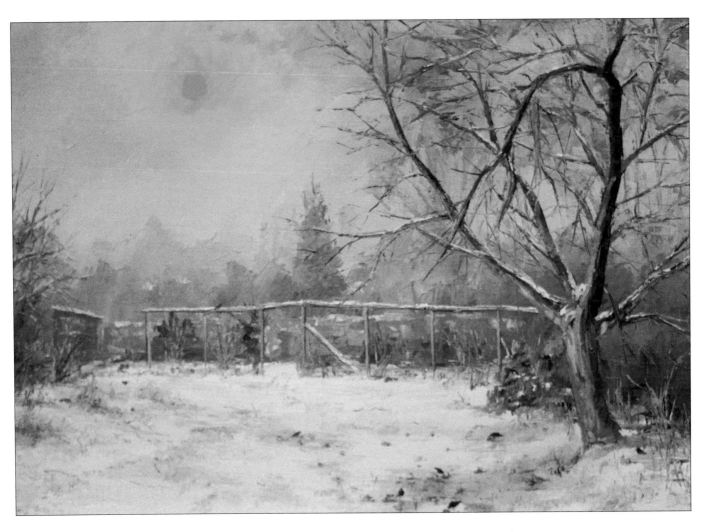

△ **Birds in the Snow,**
Brian Bennett, oil.
In this painting, earth colors are neutralized by flake white to suggest the subtle shades seen under weak winter sunlight. Birds searching for food are made conspicuous by the light covering of snow in the foreground.

▷ **Snow Lake,**
Carmen E Corrigan,
ink and pastel on sandpaper.
This almost monochromatic pastel drawing has a strong sense of rhythm, created by the predominant form of the tree on the right of the composition, whose entwined branches link together all the elements of the scene. The bridge, lake, and trees have been sharply delineated in pen and ink. Flecks of falling snow serve to heighten the wintry aspect.

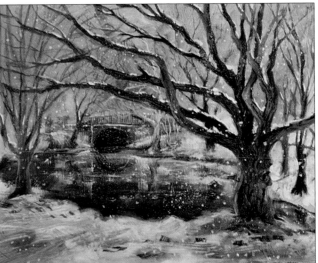

the effect of thick, wet snowflakes, or a swirling snow storm, spatter onto the painting while it is still damp to produce a more blurred effect.

An alternative technique in watercolor is to spatter masking fluid onto the paper before beginning the painting. When the painting is completely dry, rub away the masking fluid to reveal the white paper beneath. With this method the snowflakes produced are more sharply defined, because masking fluid dries with a hard edge.

For a more delicate effect, try sprinkling a few salt crystals into the paint just before it loses its shine. A little star forms around each crystal as the salt soaks up the paint and when dry, these forms resemble soft snowflakes. Once the salt is applied, leave the painting in a horizontal position for at least 10 minutes before brushing away the salt. The best results are obtained with rock salt or sea salt rather than ordinary table salt.

Dawson ©

Stormy weather

- **Rain**
 Observing stormy weather
 Storms
 In focus: stormy sea
 Demonstration: stormy skies
 Wind
 Working from photographs
 Palettes for stormy weather

Rain in Hell's Kitchen,
Doug Dawson, pastel.
In order to gain maximum
effect from color values,
the artist has used a dark
ground. The lights from neon
signs, café windows, and car
headlights are reflected in
the wet road surface,
producing a highly
atmospheric impression of
night time in the city. At
nightfall, forms are barely
perceived, and the strong
primary colors of street
signs produce an almost
abstract quality. The balance
of all the related elements in
the composition is critical to
the success of the drawing.

T he joy of painting weather is founded on the infinite variety it provides as a subject and maybe, too, on the feeling that you can never be fully satisfied with your results – never quite catch it the way it is – which merely means you go on trying. Have you ever tried to capture the drama of a summer storm? The tension of the oppressive heat; the thunder stalking you as it echoes in the hills; electric shafts of lightning, illuminating the landscape for a split second. Where do you begin? The answer is to plunge in and paint – everything is happening so fast, there is no time to dither. At the time you may feel you have not done justice to your subject, but often when you look back on your work, you find that the essence is there, and that is what matters. When you paint a picture, it is your own, unique interpretation of what you see. You cannot include everything and therefore what you decide to omit, or what you decide to focus on, becomes your statement as an artist.

Whatever your approach, you will find the drama of nature infectious. If you are brave enough, you can follow in Turner's footsteps and paint storms on the spot; Turner maintained that only by experiencing the full fury of the heavens can an artist convey such atmosphere in his work. This need not entail getting soaked, however; you can work from the shelter of a car or from a window or doorway and still experience the full force of the drama being enacted around you.

Rain

To portray a rainy day, you can either define a scene realistically, or let the paint itself suggest "rain" in a more abstract way. This is relatively easy, of course, with a fluid medium such as watercolor. You can, for instance, paint the upper area of the sky with heavy washes and then tilt the board downward so that the color drifts down toward the horizon, giving an effect of veils of rain in the distance.

A cloudburst lit up in the distance, with shafts of
(*Continued on page* 128.)

The sheer power and drama of a storm make it one of the most exciting weather conditions to tackle

▷ **Closure of the Maerdy Pit, Rhondda Fach**,
David Bellamy, watercolor.
In this painting of a Welsh mining community marching from a coal-mine in driving rain, Bellamy uses the expressive qualities of the watercolor medium to underline the pathos of the subject. Broad diagonal washes of gray indicate the heavy rain which partly conceals the contours of the surrounding slag heaps. The figures are loosely indicated, their reflections blurred wet-in-wet on the road.

◁ **Passing Rain, Dieppe**,
Trevor Chamberlain, watercolor.
This weather-beaten French channel port is strongly atmospheric and has inspired many painters, including Walter Sickert, who said, "The color in the light must be the sister of the color in the shadows." Here, in fact, Chamberlain puts this theory into practice; we see how the rich terracotta color of the roof, for instance, glows against a dark indigo sky produced with a wash of Payne's gray. The composition is a harmony of vertical forms and structures, which combine to give a sense of visual unity to the painting.

Stormy weather studies

It is useful to file photographs, taken
yourself or cut from magazines, to help you
remember details and to inspire you when
ideas are scarce.

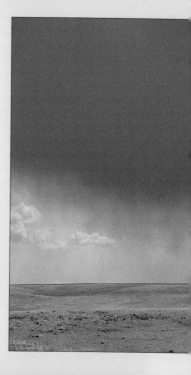

▽ Heavy storm clouds (cumulonimbus) pile up in a forbidding
manner. When painting such clouds, take care not to
model them too much or they will come forward. Note here
how the trees overlapping the clouds help to keep them in
the background.

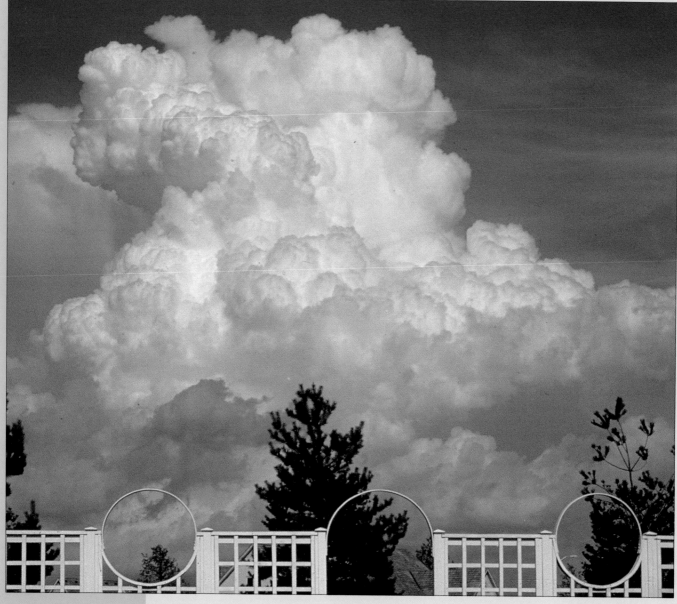

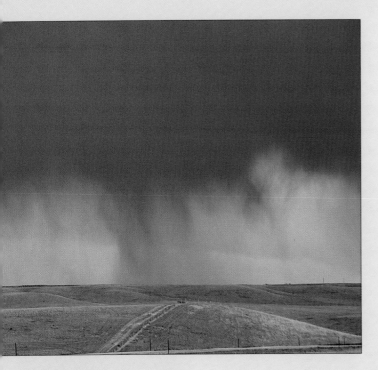

▽ The movement inherent in such a varied cloudscape would make a dramatic composition. Storm clouds need careful tonal observation; although these are dark, they are not as dark as the sea.

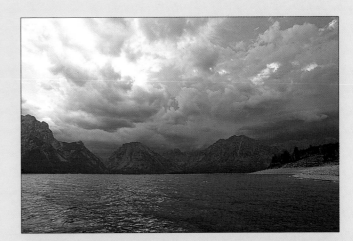

△ An almost unbelievable spring storm is captured with a camera. Reproduced in a painting, credibility might be stretched. In watercolor, the two parts of the sky could be merged wet-in-wet, encouraging backruns for the falling rain.

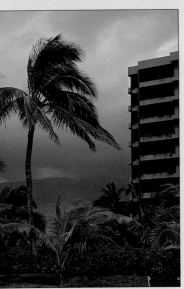

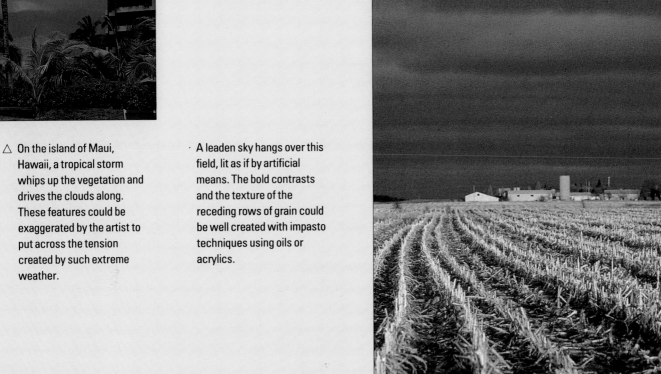

△ On the island of Maui, Hawaii, a tropical storm whips up the vegetation and drives the clouds along. These features could be exaggerated by the artist to put across the tension created by such extreme weather.

· A leaden sky hangs over this field, lit as if by artificial means. The bold contrasts and the texture of the receding rows of grain could be well created with impasto techniques using oils or acrylics.

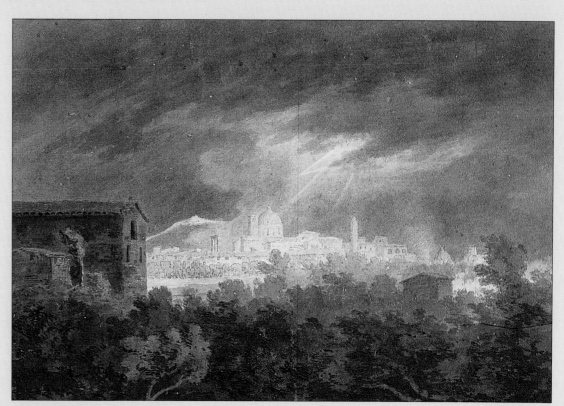

Padua, *John Robert Cozens,
after 1782, watercolor,
10 × 14in. (26 × 32.2cm),
Tate Gallery, London.*
This small finished watercolor
was based on a drawing made
at the time of the storm. Cozens
has caught the exact moment
when the buildings are
illuminated by a flash of
lightning. Although seeming to
be in monochrome, closer
observation will show the
subtle use of warm and cool
grays, hints of yellow and
green in the clouds, and a
small patch of clear blue water
visible through the trees. The
subtle control of shade has
been reached through over-
lapping broken washes in the
sky. In the foreground, the
building and foliage are picked
out in indigo overpainted on
subdued hues of olive green
and burnt umber.

rain teeming down, always looks dramatic. In water-
color, try lifting off fine, diagonal shafts of rain from
your sky wash, using a cloth wound around the handle
of a brush. If you use oil pastels, you can charge your
brush with turpentine and create shafts of rain by
smoothing and lightening the sky color already laid
down. In any medium, rain can be suggested with faint
drybrush strokes in a shade either slightly lighter or
slightly darker than that of the sky wash.

To suggest falling rain closer to the foreground,
the corner of a sharp blade can be used to scratch back
to the white ground to make slanting lines. This method
can be used with oils, acrylics, or watercolor, but take
care not to overdo it; otherwise, the effect will be
clumsy and clichéd; the merest hint is all the viewer
needs to get the message.

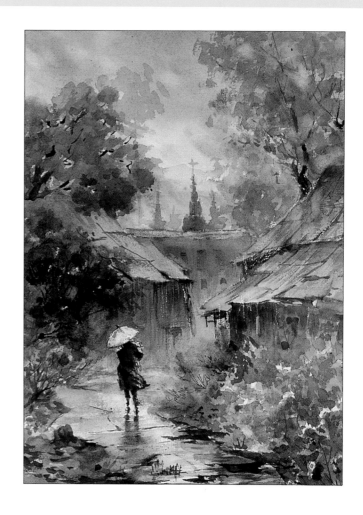

Rainy Morning,
*LaVere Hutchings,
watercolor.*
The influence of Chinese
watercolorists is clearly
seen in this painting. The
body of the brush has been
used for laying washes of
flat color, and the tip for
bringing a calligraphic
quality to the drawing of
shanty huts and trees.

1 Roughly equal proportions of ultramarine, cadmium red, and burnt umber are mixed together to produce a shade representing a stormy sky. The color is applied to the paper with a broad brush.

2 When dry, a second glaze of ultramarine and cadmium red is overlaid on the first color. This is followed by a glaze of green, which creates added depth.

1

3

2

4

5

6

3 Using a fine softhair brush and opaque white modified with a touch of red, the path of the lightning is carefully executed on the dark ground.

4 We can see that the resulting line is too sharply delineated to suggest lightning.

5 In order to remedy this, a round stencil brush is used to blur the paint slightly before it is quite dry.

6 Finally, the highlights are picked out, again using a No. 1 softhair brush, with touches of pink on the lightning and ocher where the lightning meets the horizon.

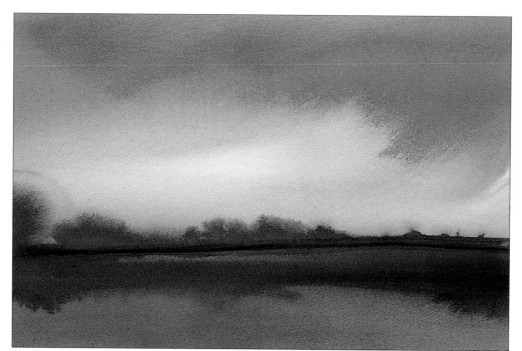

Often, though, it is more effective to imply the effects of rain on the surroundings. Moisture in the air acts like a veil on the scene, and the effects of atmospheric perspective are evident over surprisingly short distances. Generally, the shades are dark during a rainstorm, but here and there you might see a bright patch where light reflects off puddles and wet rooftops.

A picture painted after a rain shower is full of glistening highlights as wet areas – rooftops, roads, and sidewalks – act like mirrors, reflecting sunlight and imparting a clean, fresh mood to the scene. To heighten the effect, take the opportunity to include figures with brightly colored clothes and umbrellas.

Storms

There are storms at all times of the year, in all parts of the world – monsoons, typhoons, blizzards, sandstorms. Sometimes they inflict destruction on a vulnerable landscape, but the awesome power and beauty of a storm is irresistible to the artist, presenting him or her with a special challenge. When painting storms, you can imitate nature and literally throw the paint onto the canvas, spattering and working in vigorous brushstrokes to give vent to your expressive nature. But equally dramatic scenes are built up laboriously in tiny brushstrokes with minute attention to every wave and splash. In such paintings, the fact that the artist spends so much time creating what took nature a fraction of a second to perform creates a tension all of its own.

To characterize a particular type of storm, choose your medium carefully and use appropriate techniques. Watercolor is ideal for representing the dramatic play between light and water which is often a feature of such weather. Body color or gouache can be used to build up highlights or, spattered on in the later stages,

(*Continued on page* 135.)

△ **Summer Lightning,**
Michael Warr, watercolor.
The forms in this painting are very clearly defined; there is a strong sense of pattern and symmetry. The brilliant yellow flowers in the alpine meadow are separated from the sky by a rich and atmospheric graduated wash of purple-black. Forked lightning is reversed out of a wash of Payne's gray in the sky, to dramatic effect.

Stormy sea

In this feature, we look at a painting in much closer detail, focusing on aspects of the work which solve common problems or are particularly interesting from a technical point of view. This wonderfully atmospheric painting, by Paul Kenny, is dramatic in its simplicity.

▽ The yawl is added with a fine brush in the later stages of the painting. Note how the yellow-gray color of the sky has been taken over the landmarks on the skyline to push them back.

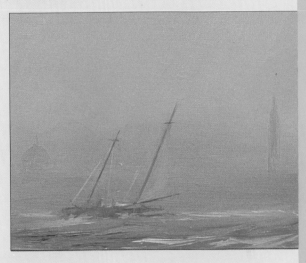

◁ ◁ In a rich, light-filled expanse of sky, evolved from layers of colored grays, these clouds are added last, leaving the brushmarks visible in the impasto strokes.

▷ The swell in the sea is painted with directional strokes of impastoed paint, letting the pressure of the brushstroke blend into the wet paint beneath, but leaving edges of pure color glistening in relief.

Stormy skies

To express the drama of the oncoming storm, David Curtis has used expressive brushwork, avoiding getting bogged down in detail and maintaining a broad rhythm throughout. He has chosen to allow the sky area to dominate the picture space, dwarfing the alarmed-looking farm buildings below, and making a statement about man's submission to the elements. Using oils allows the artist to move the paint around on the canvas, trying out ideas. Yet the paint here remains fresh and in no place overworked. The impastoed highlights add greatly to the textural interest of the picture surface, catching the light and leading the eye through the composition.

● **Colors**
French ultramarine
Cerulean blue
Light red
Raw sienna
Naples yellow
Viridian
Burnt sienna
Titanium white

● **Support**
A canvas covered board,
20 × 24in. (51cm × 62cm).

● **Brushes**
A range of chisel-edge brushes,
sizes 1 to 10.

4 A thicker impasto of paint is now used to firmly register the main forms in the composition. The middle shades in the sky are modeled to create a sense of volume.

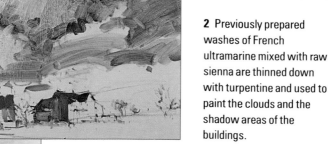

3 Colors continue to be blocked in quickly, establishing a tonal pattern which can be further modified. Lighter areas of sky are added after standing back from the painting to evaluate the progress so far.

2 Previously prepared washes of French ultramarine mixed with raw sienna are thinned down with turpentine and used to paint the clouds and the shadow areas of the buildings.

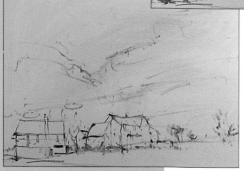

1 The board has been given a preliminary priming coat of gesso. When dry, the artist loosely outlines the composition, locating the main landscape forms and the foreground buildings.

1

6 The dark shapes of the windswept trees on the horizon are defined by cutting into the contours with patches of cerulean blue and white. This method creates a sense of space behind the trees.

6

7 The artist now gives more definition to the light and dark shades of the clouds, providing a keynote to the whole painting.

7

8

5 Details such as the roof, windows, and doorways are painted in darker shades to provide further contrast. Great care is taken to maintain a consistently broad rhythm of brush-strokes throughout; too much attention to detail can render a landscape lifeless.

5

8 Detail of the finished painting shown below.

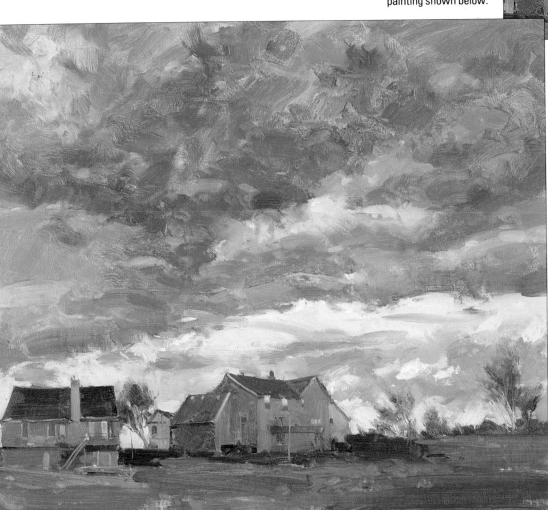

Stormy skies,
David Curtis, oil.
The painting is now complete. The secret of success when painting weather effects lies in paying close attention to tonal relationships and to hard and soft edges, particularly in the cloud forms.

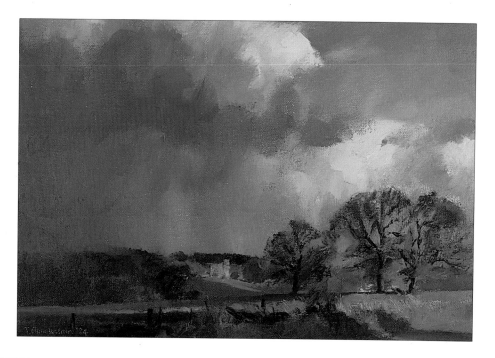

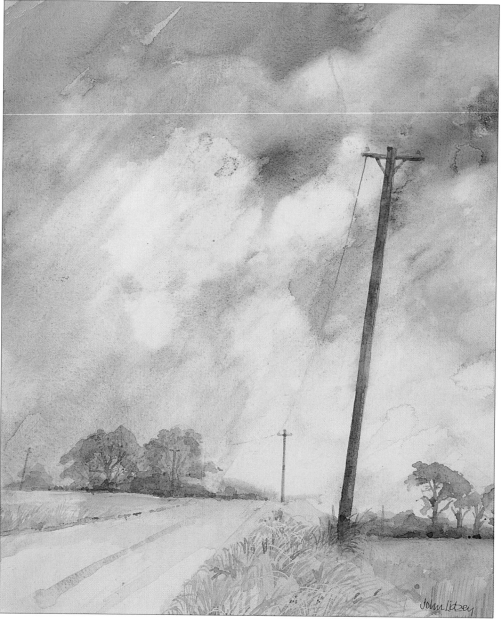

△ **April Raincloud Over Ware Park**, *Trevor Chamberlain, oil.*
This painting demonstrates how the sky can be employed as an integral part of the composition. A shaft of sunlight pierces banks of billowing storm clouds, to illuminate the facade of a country house. The low-lying landscape is rendered in soft tones of blue-gray, raw umber, and olive green.

Landscape,
John Lidzey, watercolor.
The sky dominates this composition, occupying three-quarters of the picture plane. Two telegraph poles, viewed in steep perspective, serve to link the foreground to the distant horizon. Pallid washes of color are brushed on loosely, wet-in-wet, to suggest the constant shifting of clouds and light.

Snow Storm – Steam Boat off a Harbour's Mouth, *J.M.W. Turner, 1842, oil on canvas, 36 × 48in. (91.5 × 122cm), Tate Gallery, London.*
The drama of the storm is created here through a vortex of light, emphasized by the encircling network of rapid brushstrokes. Over a white ground, Turner worked an underpainting of dilute paint, on which he built up layers of thick paint. The effect of the swirling snow, witnessed directly by Turner, who had himself strapped to the mast of the *Ariel* for four hours, is created with sweeping, scumbled strokes over the already broken surface, echoing the motion of the angry waves and leading the eye to the focus of light.

Approaching Storm,
Elizabeth Apgar-Smith, pastel.
This painting captures all the drama of the moment just before the break of a storm. The tiny figure hurriedly bringing in her washing is engulfed by a vortex of movement as the wind ransacks the trees, the grass, the clothes on the line. Short, diagonal strokes of pastel accentuate the feeling of tension in the air, as do the lurid colors and strong contrasts of light so typical of an approaching storm.

to represent sea spray or wind-swept rain.

Acrylics perform well in painting storm scenes; they dry quickly between applications, so that atmospheric effects can be built up speedily with layers of drybrush, scumbling, spattering, and impasto strokes with brush or knife. Oils may take longer to dry, but these same techniques are possible, and the paint stays wet long enough to allow you to change your mind as the drama unfolds. You can build up the paint, or you can work into it, using sgraffito marks to give texture, or scratching back to the primer or ground.

The immediacy of pastels is effective in capturing the movement and energy of a storm. Use a limited palette of colors, and start at the point of interest

Landscape, *David Curtis, oil.*
This diminutive study captures a moment in a shifting pattern of light which so characterizes the climate of northern Europe. Sunlight filters through banks of ocher-gray cloud to illuminate the surface of the water. Fresh greens are used to depict the kind of landscape seen after rain. A tiny crofter's cottage lends a sense of scale to the painting, and the road acts as a visual link from one side of the composition to the other.

before it has a chance to disappear.

A storm is often accompanied by eerie lighting effects, both in the sky and on the landscape. Suggest the ominous sky by painting the upper part in dark shades, leaving a narrow strip of light tone just above the horizon. In watercolor, leaving small patches of white paper in the sky wash is effective in indicating bright light (or lightning) shining through gaps in the clouds.

Storm clouds aren't just gray, but contain hints of brown, violet, and indigo. Mix a selection of warm and cool grays from ultramarine, burnt sienna, Payne's gray, burnt umber, yellow ocher, and violet (plus white in opaque media). Don't be afraid to use vigorous, sweeping brushstrokes, strokes that reflect the violent movement of the clouds and encourage the eye to move across and around the picture.

Wind

Of course, you cannot actually paint a gust of wind. You can only suggest its presence by showing its effects on

Storm Rolling In,
Pat Pendleton, oil pastel.
This is an example of how high-key colors can be used to great effect. Vigorously hatched strokes throughout denote a sense of vibrancy while unifying the elements of the landscape. The effect conveyed is of a landscape caught in a brief interval of sunlight.

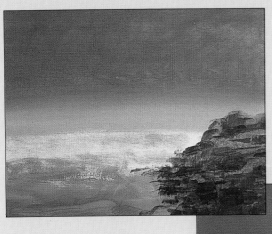

1 The dark shade of the sky is made up of ultramarine, cadmium red, raw umber, and white fused together. The sea is almost viridian and is produced by mixing emerald green with cadmium yellow and white. A dry brush is used to lift off some of the color just before the paint dries.

2 The rocks provide the darkest shade in the painting and are defined by soft shades of ultramarine mixed with raw umber. As the painting develops, dry white pigment is whipped across the rocks to suggest spray and the crests of the waves.

3 The formation of a wave crashing against the rocks is tentatively suggested using a wet-in-wet technique to blend the colors together.

4 The wave is firmly established with thicker white paint. The dramatic spray is produced by using the pigment fairly dry and dragging it across the surface, creating an upward movement.

5 Finally, highlights are added to the waves and the painting is given greater contrast to evoke the dramatic mood of the scene.

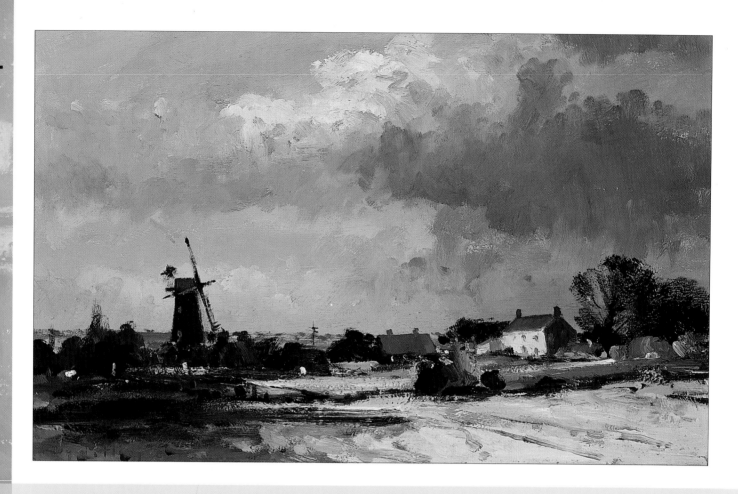

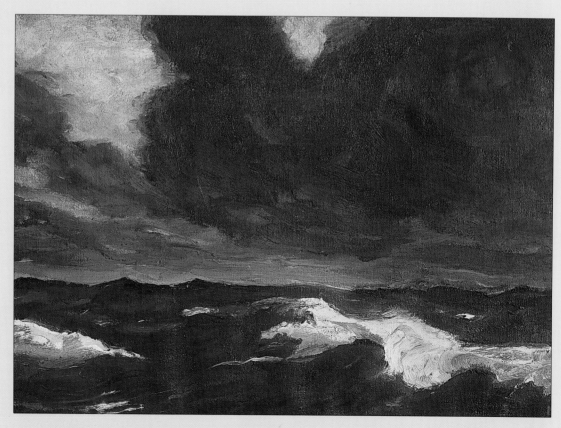

The Sea, *Emile Nolde, 1930, oil on canvas, 29 × 40in. (73.7 × 101cm), Tate Gallery, London.* The deep brooding drama of a stormy sea has been captured here with great simplicity through high contrasts, expressive brushwork, and touches of savage color. The dark cloud has been built up with layers of dark violet-grays and greens worked wet-in-wet into the oranges and yellows of the freakish, backlit sky. Note the strokes of dense green on the left, resting on the surface. Below, the boiling sea is indicated more by directional brushwork catching the light than by color. This painting reflects the very personal vision of the artist; it is more an emotional response to the subject than a direct study from nature.

◁ **Passing Storm, Sea Palling,**
Roy Petley, oil on board.
The sky, more than any other element, can greatly influence the mood of a landscape view. Here it provides a key note to the painting, and the horizon line is kept deliberately low to heighten this effect.

▷ **To White Moor, Cornwall,**
Lionel Aggett, oil.
This painting reveals the influence of both Turner and Constable in the treatment of the sky and landscape. Rendered with repeated strokes of dilute paint, heavy squalls of rain fall vertically, pounding the moorland. A tiny farmhouse gives the painting a sense of scale.

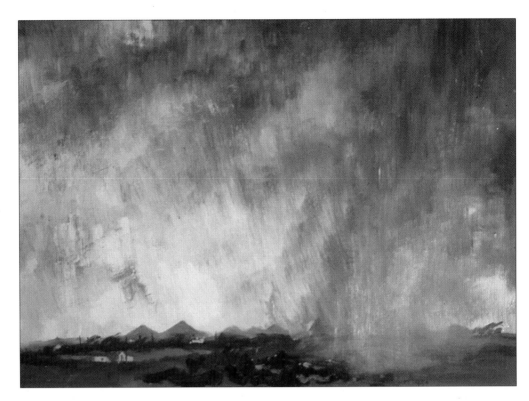

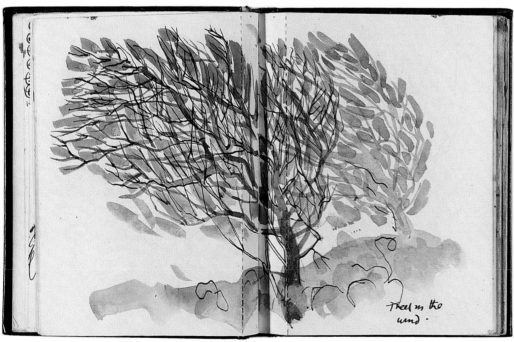

◁ **Tree in the Wind**
(sketchbook study)
Ray Evans, watercolor and pen and ink.
Trees are shaped by the elements – wind, rain, and snow all help to determine the shape and direction of their growth. This sketch is rapidly executed in washes of blue and Indian red. Branches of the tree are defined with pen and ink.

the landscape – trees bowed, their branches waving, clouds scudding across the sky, and so on.

If you are painting a stormy seascape, you can give an impression of high winds by emphasizing the crashing waves. Use sweeping, irregular strokes that reflect their violent movement.

In a townscape, buildings remain stoically erect in the face of a gale, so you will need to search for other visual clues – blown rubbish or leaves, awnings flapping and figures leaning into the wind and clutching their hats, their hair and scarves trailing behind them.

You may however find that mere hints such as this are not enough to put across what is in effect a physical assault. A strong wind bites into you, throws you off your balance, and blows dust into your eyes. So an artist, like an actor, often has to be theatrical in gesture to make a point. Compose your picture so that the eye is drawn to your clues and then exaggerate them: make scarves flutter uncontrollably, trees bend almost to breaking point, clouds of dust arise from the windswept street.

Working from photographs

Photographs are thought by some artists to be a lazy way of recording information, almost a form of cheating. While it is certainly true that copying from a photograph

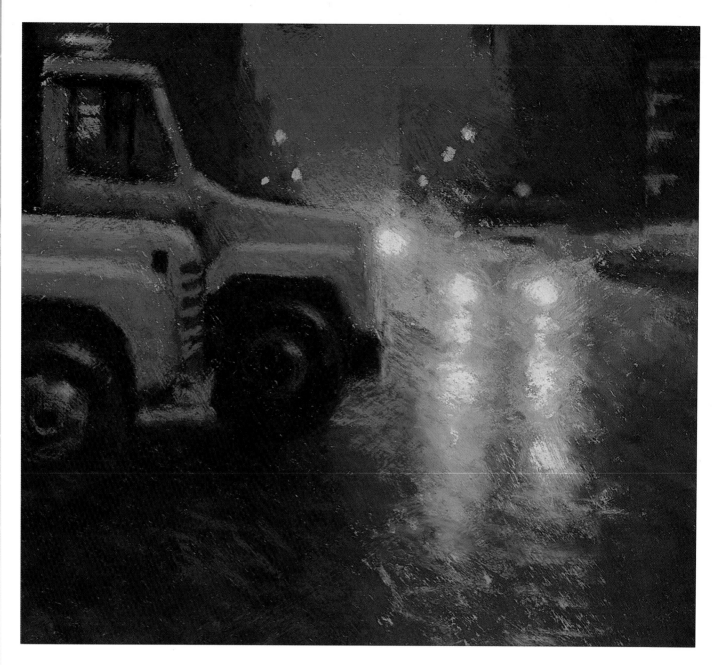

is rather a tedious way of spending time, using a photograph as an image to jog the memory, or as an objective way of looking at the world, can be very useful.

For example, take lightning. It happens so fast you do not have time to see what is happening, let alone record it in paint. Photographing it is not easy either, but if you study the successful attempts of a professional photographer, you will see how much this phenomenon can differ in structure and color.

Black and white photographs can help enormously in assessing the tonal values of a scene. But even then you cannot rely on the view of the camera, and if you studiously reproduce what it records, you will generally find the result flat and devoid of subtlety. Don't feel inhibited about manipulating areas of shade where necessary in order to make sense of the picture or to improve the composition. There are many reasons for doing this – for example, to lead the eye to the focus of the subject, to help unify the painting, or to exaggerate a feeling of recession.

Trucks on Market,
Doug Dawson, pastel.
Color plays an important part in suggesting mood and atmosphere in this night scene. The reflections of the car headlights in the wet road are heavily scumbled, the marks giving an impression of rain lashing down.

WATERCOLOR

Brave washes of stark colored grays are suffused wet-in-wet for soft gradations of shade and applied wet-on-dry for hard edges. The formation of the clouds is mainly intuitive, but based on sound knowledge and observation. Notice the granulation of the dark wash on the right, made from a combination of ultramarine, raw umber, and Payne's gray.

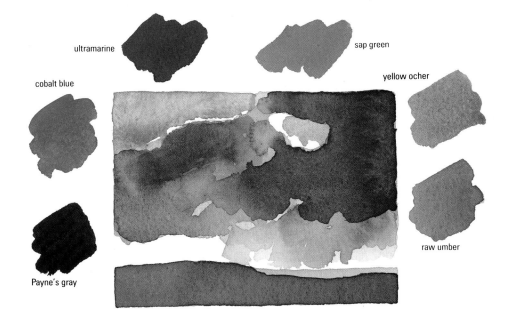

ultramarine · sap green · yellow ocher · cobalt blue · raw umber · Payne's gray

OIL/ACRYLIC

Close observation of clouds will reveal a surprising variety of colors, which can be exaggerated for dramatic effect. Here, burnt sienna has been blended with dark blue grays and titanium white to evoke heavy rain clouds. The vertical brushwork in the blue-gray sky near to the horizon gives the impression of rain falling.

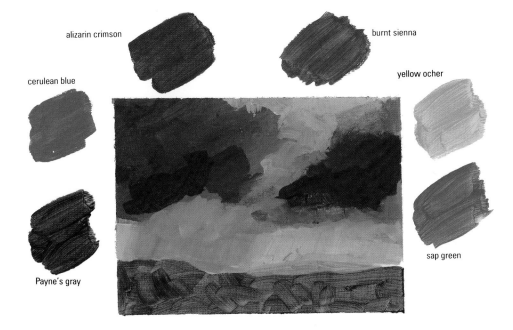

alizarin crimson · burnt sienna · cerulean blue · yellow ocher · Payne's gray · sap green

PASTEL

Blending and scumbling these pastels has produced a rich depth of color and shade. Particularly impressive is the white highlight between the clouds, which is scumbled with the flat of the pastel stick over light blue gray and ocher. Once again, allowing the white paper to show through the darker colors is an effective technique.

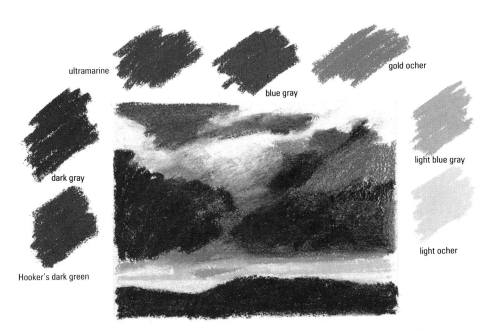

ultramarine · blue gray · gold ocher · dark gray · light blue gray · Hooker's dark green · light ocher

Index

Page numbers in *italics* indicate captions to illustrations.

Credits

The author and Quarto would like to thank all the artists whose work appears in this book. Thanks to the following organizations for permission to reproduce copyright material:

p67(b) Dallas Museum of Fine Art, Munger Fund.
p87(t) courtesy of the Pennsylvania Academy of the Fine Arts, Philadelphia. Joseph E. Temple Fund.
p94(b) © Photo RMN.
p111(t) © Photo RMN.
p75(t) © 1992 Indianapolis Museum of Art, John Herron Fund.

UNICORN STOCK PHOTOS: Martha McBride (p28b), Gerry Schnieders (p28m), A. Gurmankin (p29t), Lowell Witcher (p29tr), Bets Anderson (p29b), Dede Gilman (p29br), Martha McBride (p56m), Ann Woelfle Bater (p56b), Travis Evans (p56r), Unicorn (p57t), Karen Holsinger Mullen (p57m), Ann Trulove (p57b), Rod Furgason (p84t), Marie Mills/ David Cummings (p84b), H. Schmeiser (p85t), Tom Edwards (p85b), Ron Jaffe (p85tr), Bets Anderson (p85br), Robert Vanki (p126b), Dick Young (p126t), Bets Anderson (p127m), Judy Hile (p127b), Travis Evans (p127t), Robert Hitchman (p106l), Charles Schmidt (p106r), Jim Riddle (p107l), Robert Hitchman (p107m), Dave Lyons (p107b).

With special thanks to the artists who did demonstrations: Lincoln Seligman, Ian Sidaway, John Martin, Hazel Soan, Jean Cantor, Paul Wright, David Carr, David Curtis, and James Horton.

Special thanks also to John Elliot in New York, who researched pictures by American artists.

Every effort has been made to trace and acknowledge all copyright holders. Quarto would like to apologize if any omissions have been made.